Boudoir
PHOTOGRAPHY

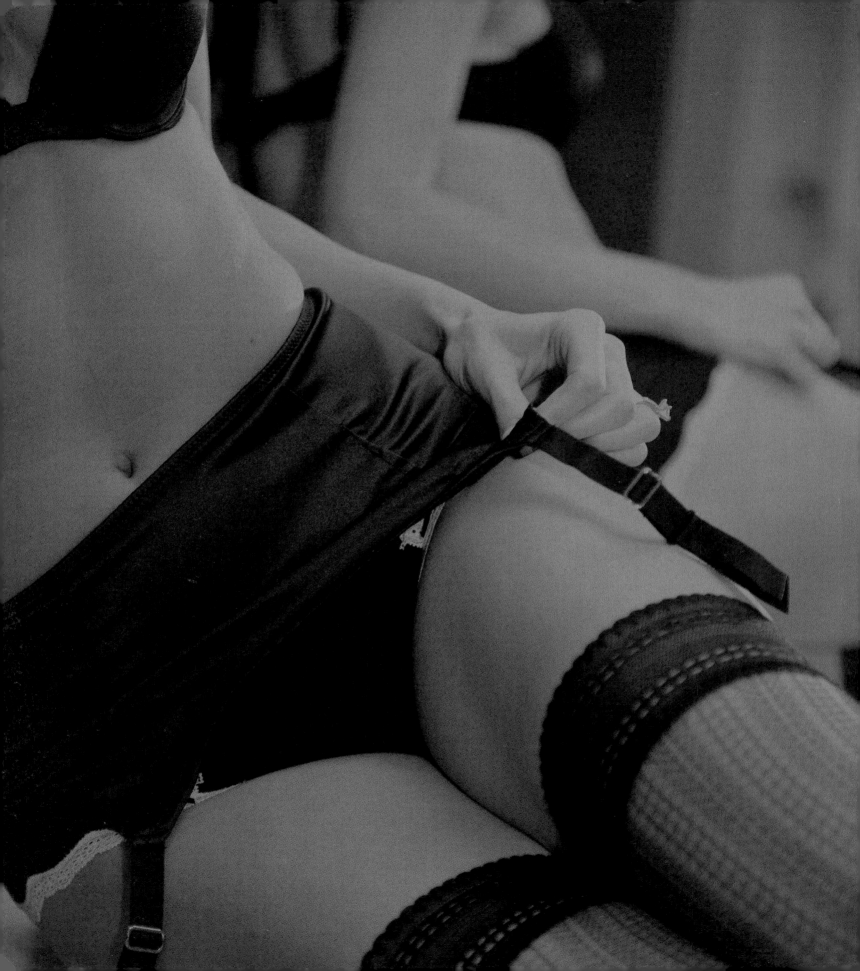

Boudoir

PHOTOGRAPHY

The complete guide to
shooting intimate portraits

CRITSEY ROWE

AMPHOTO BOOKS

an imprint of the Crown Publishing Group
New York

Published in the United States by Amphoto
Books, an imprint of the Crown Publishing Group,
a division of Random House, Inc., New York
www.crownpublishing.com
www.amphotobooks.com

Amphoto Books and the Amphoto Books logo
are trademarks of Random House, Inc.

Originally published in Great Britain as
Boudoir Photography by Ilex, an imprint of
The Ilex Press Limited, Lewes.

This book was conceived, designed and produced by
The Ilex Press Limited,
210 High Street, Lewes, East Sussex, BN7 2NS, UK

PUBLISHER: Alastair Campbell
CREATIVE DIRECTOR: Peter Bridgewater
ASSOCIATE PUBLISHER: Adam Juniper
MANAGING EDITOR: Natalia Price-Cabrera
EDITORIAL ASSISTANT: Tara Gallagher
ART DIRECTOR: James Hollywell
DESIGN: JC Lanaway

Library of Congress Control Number: 2011920637

ISBN: 978-0-817400-11-8

Printed in China
Color Origination by Ivy Press Reprographics

First American Edition

10 9 8 7 6 5 4 3 2 1

Contents

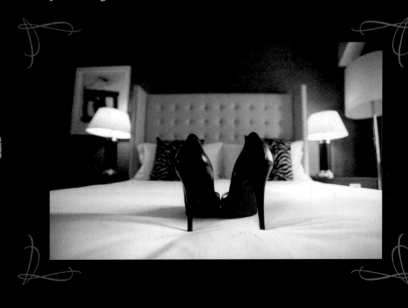

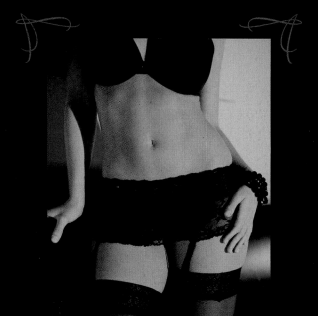

Introduction

Boudoir...sounds luxurious and sexy doesn't it? That's because it is! Although boudoir photo sessions are not a new trend, boudoir has become increasingly popular the last few years. More and more women are having sexy, intimate fashion portraits taken for their boyfriends or husbands, and even just for themselves. Women are usually nervous at the beginning of the session, but after a few minutes they relax and reveal their inner sex goddess.

The sessions can be a great gift not only for the guys but a wonderful gift for the women themselves—a special way to capture their own beauty and unique sexiness.

Boudoir sessions can be set in any location: in a studio, the client's home, a boutique hotel, a bed-and-breakfast inn, or a special location. The sessions can be like a fashion shoot, often including many wardrobe changes and sometimes a personal hair-and-makeup stylist to create different looks, so the client ends up with lots of gorgeous, sexy portraits. Unique details—from vintage hats and Mardi Gras masks to shooting in a modern high-rise penthouse—can add to the high-fashion feel of the shoot, make the session unique, and give the client a variety of beautiful images.

Boudoir photography makes a sexy gift, and any woman can be made to look fabulous, no matter her age, size, or nationality. It's a whole new portrait market for photographers wanting to expand their repertoire.

RIGHT: *This photo represents a modern lifestyle boudoir portrait.*

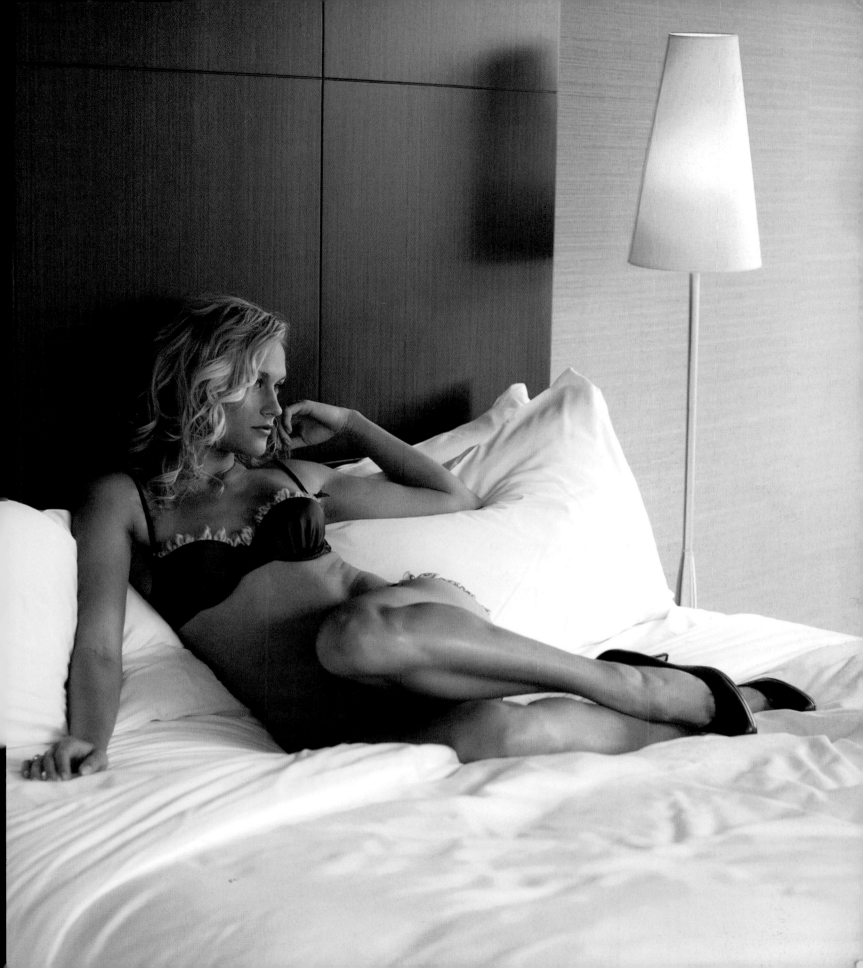

Finding Your Feet

❧❧❧❧❧❧❧❧❧❧

When you're starting out, ask friends and past clients to model for you to help build a stellar portfolio—you must be able to show what you want to sell! Even if you have just one session under your belt it will be much easier to book another. Offer a discounted rate to past clients until you reach a level where you have enough portfolio work to feel confident to sell to other potential clients.

History of boudoir photography

Boudoir is a French word meaning "to pout or sulk" and also refers to a woman's dressing room, which naturally leads the mind to intimate things. In this century "boudoir" has become the term for this genre of photographic art—intimate and beautiful portraits of women in lingerie.

BOUDOIR PORTRAITS are not a new thing; the trend goes back hundreds of years. A glimpse through the history of the masters of painting reveals many artfully done boudoir sessions, including paintings by Édouard Manet, Peter Paul Rubens, and Francisco Goya. All through history you can find images of women depicted in paintings or drawings with little to no clothing.

With the advancement of technology in this century, many photographs have been taken of women in various poses implying nudity, and many fully nude. Pinup photography became popular in the 1940s and 1950s, with women sending these types of images to their boyfriends and husbands deployed in wartime. Even today women send photographs to their men in the military as keepsakes and to remind them of what is waiting at home.

More and more women are seeking these types of photographs to give as a gift or to keep for themselves. These images can be very liberating and empowering and a way to capture their unique womanhood. Boudoir photographs are popular not only for young brides but also for women of any age. Change can be a big reason for women to have boudoir portraits taken for themselves. Some women may commission the session to document a change in their appearance, whether it is plastic surgery or weight loss.

TOP RIGHT: *Boudoir has changed over the years, and more and more women today seek professional boudoir portraits because it is viewed as more tasteful than in the past.*

RIGHT: *Clients are seeking images that are sexy, modern, and tasteful.*

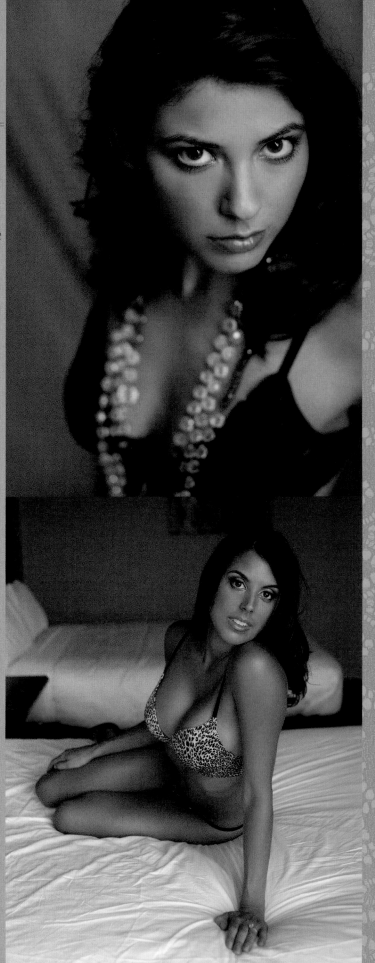

Boudoir photography today

Boudoir photography has come a long way and is still evolving. It often forms part of a photographer's repertoire alongside fashion, wedding, and portrait photography.

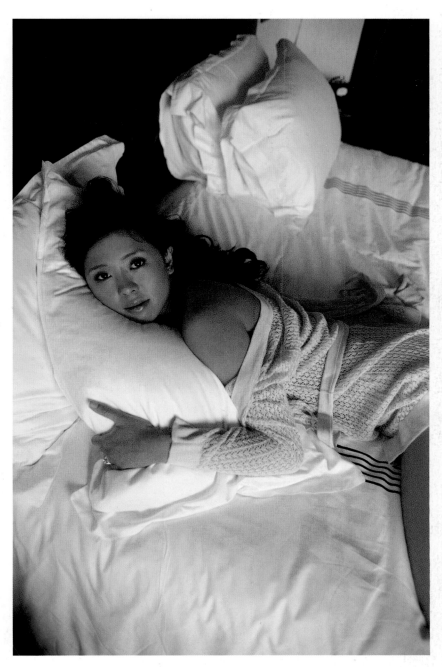

THE SKY IS THE LIMIT with boudoir photography, and the creativity and inspiration of many photographers have opened many stylistic doors, while class and tastefulness are the bonds that holds all styles together. Whether the location is a studio, a home, a store showroom, or outdoors, there are no restrictions, and a woman can pick a style that fits her personality or fulfills her fantasies. Boudoir photo sessions are so much more than just a photography assignment. They are an experience that is empowering, making the subject the center of attention and allowing her to be pampered. They capture the beauty of every woman and preserve it in the most artful way.

Our society has embraced a consciousness of the whole body and boudoir photography is the portrait style that depicts this. In contrast to so much of the nude photography that we have seen for years, and that often hides parts of the human form in shadow, boudoir photography shows and celebrates the beauty of the female body, and engages in a play with the location, accessories, and clothes that enhance and emphasize a woman's form as well as depict her own style. It is no wonder that boudoir photography now is a growing trend and women of all ages seek to have intimate photos taken in a tasteful way.

Still, I find that the term "boudoir photography" is not as well known as the style itself. Many women know exactly what they want, but they search for "lingerie photography," "sexy photography," "pinup," "nude photography"—which may or may not lead them to the results they want. Try it: Ask around, and you will find that many people have not heard the term, but once you explain it, they will all say they have seen it. This is why all boudoir photographers should spread the word and help educate models and clients that boudoir is what's hot and what they're looking for.

RIGHT: *A modern take on boudoir does not have to be all lingerie to be sexy. Have the subject bring some everyday clothing to incorporate in your session.*

Looking for inspiration

Inspiration is what enhances and evolves your style. It helps you to be unique and leave boundaries behind. Inspiration is everywhere, and if you stay open to finding it in even the most unlikely places it will allow you to stay creative even when a location is difficult and the odds seem to be against you.

Don't just look for inspiration in other photographers' work. In the end, this will only bring you closer to what others do and limit your creativity. We are exposed to a plethora of imagery, and much of it can be inspiring: magazines, advertisements, movies, art, literature, and even the everyday life around us. There is so much I pick up from sources that do not seem to have much to do with boudoir photography. But light, color, and motion are everywhere—the pose in an advertisement, the lighting in a scene from a movie, a piece of furniture I see, or a little accessory like a bracelet. Everything can make you try something new or unexpected at your next shoot.

Some of our inspiration can come from other exceptional photographic styles, such as the posing in fashion and advertising. It doesn't matter if the models are fully dressed, they can still give you new ideas. Try seeing instead of just looking. Analyze the image and ask yourself how it was done. Soon you will find that this becomes second nature to you and happens even when you don't think about it. If anything you see pushes your buttons and triggers emotions in you or others, think of how and why this happens. Often you will find that it contains elements that you can easily incorporate in your work: colors, relation of objects, contrast, play between foreground and background, and so on.

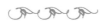

RIGHT: *I get most of my inspiration for posing from magazines. They do not need to be lingerie magazines. For instance, this pose is similar to one from a fashion magazine in which the original model was fully clothed.*

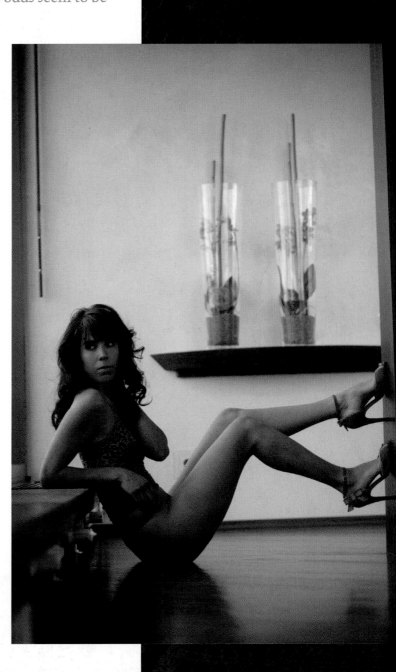

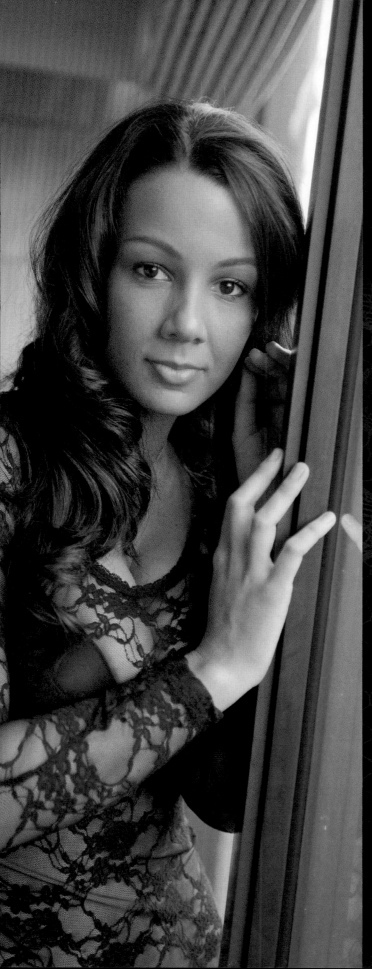

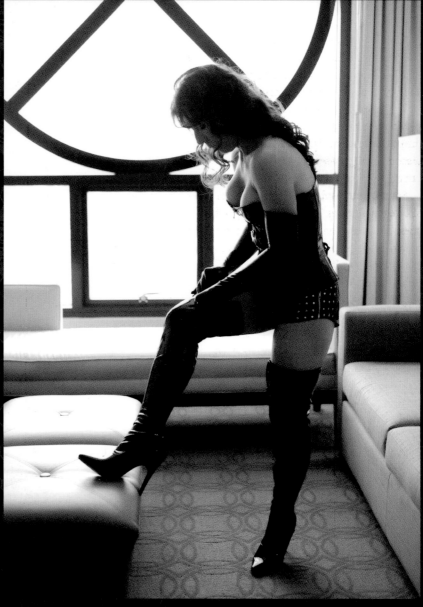

I often assemble an inspiration portfolio of tear sheets, and I save images from the Web in a folder that I can go back and revisit. Don't stop at taking in just the details. Look at the whole scene—the mood, the feel—as this is something your boudoir photography can vastly benefit from. If you watch a movie in which something inspires you, rent or buy it, watch it again, and think of how it can influence your work.

Visiting art galleries and museums is another way of getting new inspiration and widening your horizons. Paintings can give you a whole new perspective on how things can be seen.

Besides the look of a scene, a theme can be an inspiration, and something that you can offer your client. Many women love the idea of incorporating some special theme elements into their shoot.

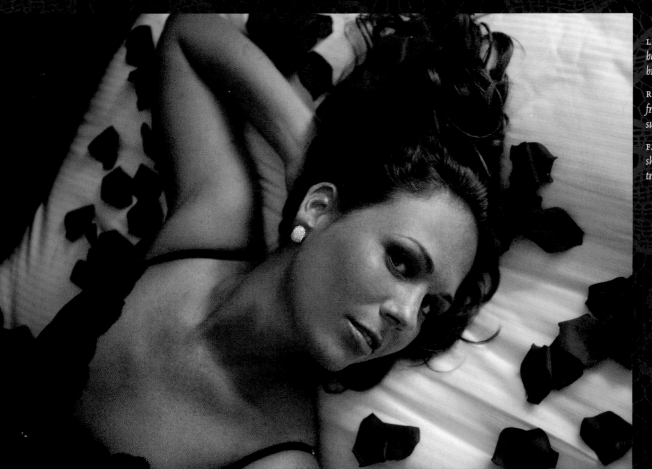

LEFT: *Your inspiration may also be the props you or the subject brings for the shoot.*

RIGHT: *Find different directions from which to photograph your subject in a standard pose.*

FAR RIGHT: *Sometimes a detail shot can be more intimate than a traditional portrait.*

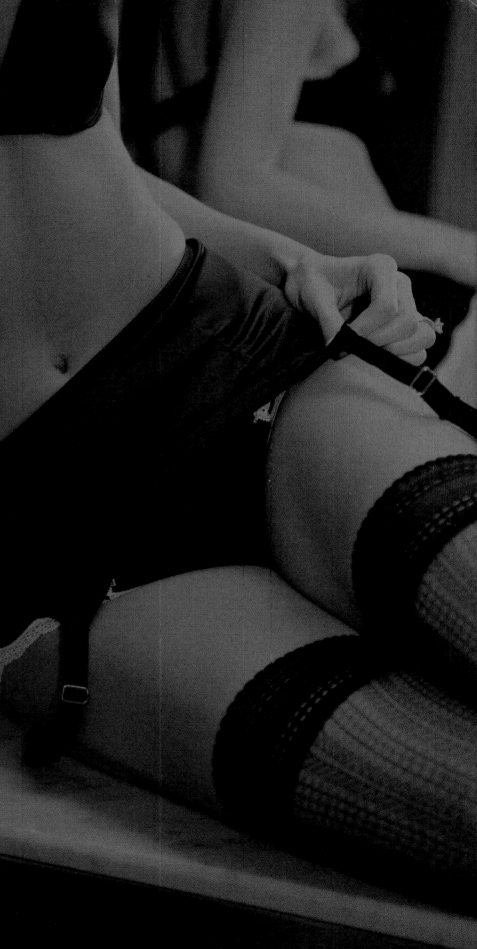

Learning and training also contribute to inspiration. Workshops and seminars, whether on boudoir photography or other photography-related topics, can bring you to the next level and enhance your vision dramatically. Join a group of photographers that does boudoir photography—it can be a great resource and can have a big impact on your work. Let me name two: Boudoir Photographers Network (www.boudoirphotographers.net) and the Digital Wedding Forum (www.digitalweddingforum.com—don't be fooled by the name; it has a great boudoir forum!)

When you find inspiration, don't stow it away and forget it. Go through your resources frequently and try to incorporate just a little in every shoot you do.

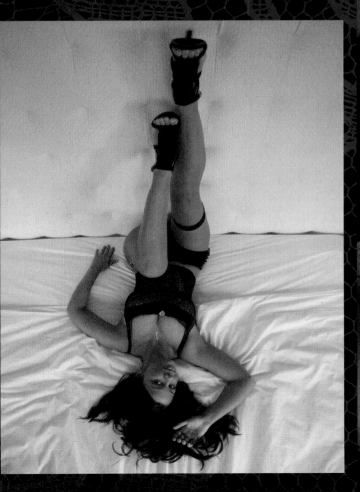

What people really want

Most women who have boudoir portraits taken plan to give the photos as a gift to their significant other. Sometimes they do the session for themselves. In either case, they will be interested in certain products to go along with their package.

Fabric-covered album.

THE MOST REQUESTED ITEM is a book of images. Offering several sizes and styles will give clients a diverse selection to choose from. Many album companies offer albums made for boudoir photographers. These albums have boudoir-style covers, such as leopard print or brocade silk, among other options. Albums come either completely manufactured and assembled or as peel-and-stick albums for a faster turnaround to the client. Bound or flush-mount albums differ in terms of the printing and presentation—a flush-mount album has the photos printed in the book as part of the page. You may supply the pre-designed spreads or prints to the album company for binding. Peel-and-stick albums come with adhesive pages for self-mounting by the photographer.

Your album customization makes a personal statement and, done well, will set your albums apart. A well-designed album makes a powerful impact. Look at examples from the album company of your choice.

Calendars, canvas prints, and wallet folios are other best-selling products. Be sure to check which, if any, of these items an album company may also provide.

Inscribed album.

Self-mount album.

> **PRO TIP**
>
> *Make sample albums in different sizes to show your clients what they may choose from. If you add folios and calendars in your packages, have a few samples on hand to share with the client. This is a great selling tool as well. If a client chooses a 5×7-inch album and you show her a 5×7-inch versus an 8×8-inch, more than likely she will want the 8×8-inch album.*

Press-printed album by ProDPI.

Acrylic-covered album.

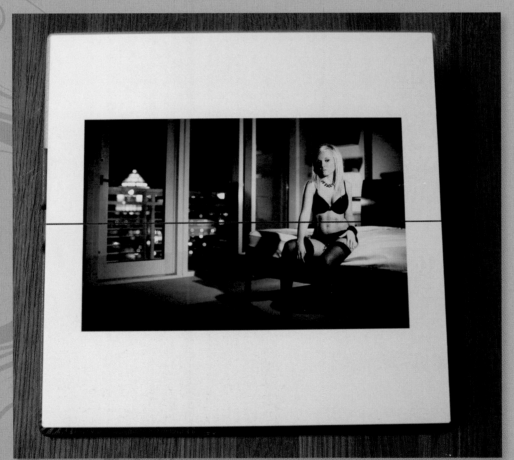

Flush-mount album bound by album company.

Male and female photographers

It is important—whether you are a male or female photographer—to have a professional website that clearly and thoroughly explains the type of work you do. With regard to boudoir photography, it is important to showcase your individual style on your site, displaying the work you are comfortable doing, so new clients will have an understanding of what to expect.

A VERY EFFECTIVE WAY to raise the comfort level of both the client and the photographer during the photo session is to have a third party present in the studio or on location. If the photographer does not have an assistant or makeup artist available to be present through the shoot, you may recommend that the client bring a friend. The presence of this third party can help put the model at ease and dispel fears, ultimately creating a more professional environment.

It is also important to note the unique perspective male and female photographers bring to a boudoir photo session. It is unfair to believe that women have a distinct advantage over men when working in this style of photography. Both male and female photographers offer a unique viewpoint that can be helpful to a client. For example, while a woman may relate to the female client in understanding what would look and feel sexy as a woman, a male photographer can offer insight as to what a man might be interested in seeing.

PRO TIP

When my clients present photos to their significant other, they are often asked who took the photos. Because of their nature, the photos are very personal, and whether the question is coming from curiosity or jealousy, all of my clients have been confident in directing their significant other to my website or other advertising. It is important to project an image that is professional on all levels so clients feel confident in sharing your work and recommending you. This also assures boyfriends, husbands, and significant others that the model is in good hands and in a professional environment.

BELOW LEFT: *Female photographers may show a more sensitive side, while men may showcase a woman's sex appeal more directly.*

BELOW: *This is a shot taken from a female perspective, but a male may have a different view on how to photograph a woman.*

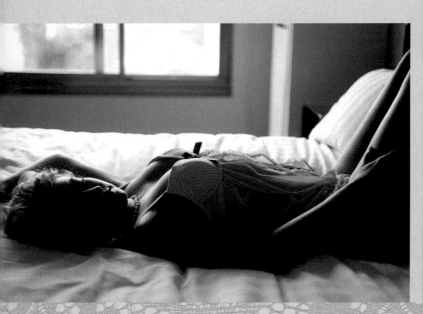

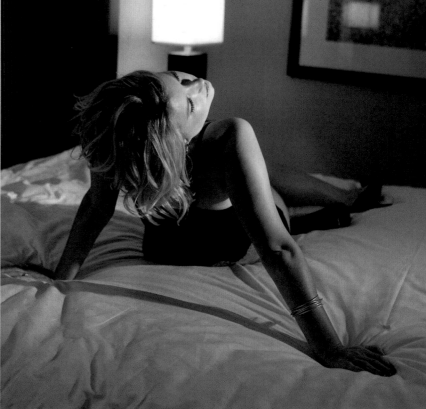

BELOW AND RIGHT: *These two photos are among those I show potential clients to demonstrate that while my work spans a range of styles—from soft, romantic, and feminine (right) to strong and modern (below)—it always remains tasteful, flattering, and sexy.*

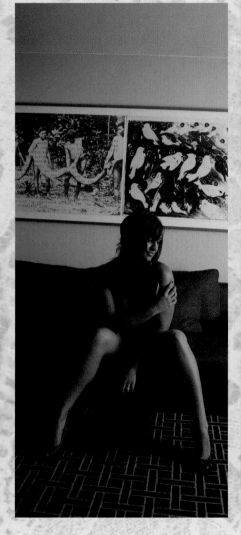

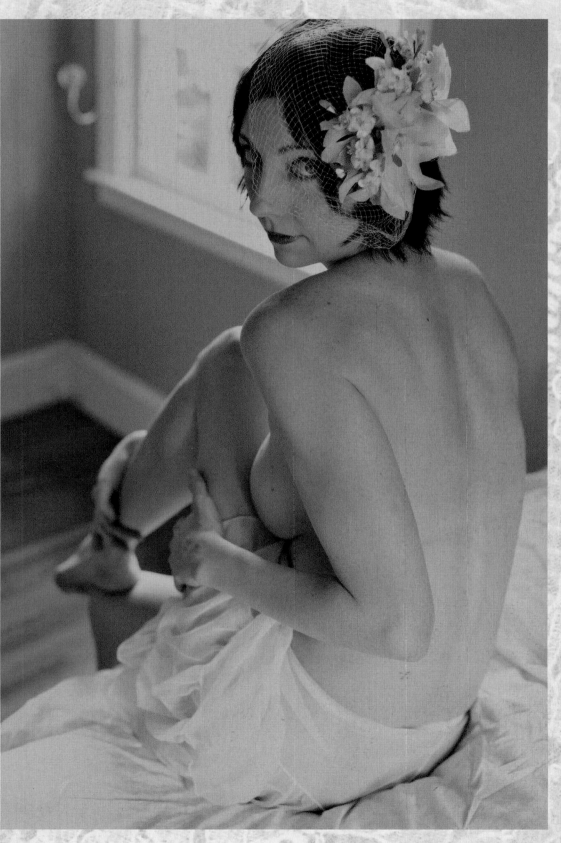

PRO TIP

Get the word out in any publications you may have access to—from small local papers to radio stations and even TV. Whenever people see the amazing quality that boudoir photography now provides they all get excited about it.

Tools of the trade: cameras

There has never been a better time for photographers than today: it is really hard to buy a bad camera. However, it makes sense to look for equipment that fits the job.

Boudoir photography is a type of portrait photography and therefore the requirements are the same as for portrait photography. The only "must" for serious boudoir photography is a single lens reflex (SLR) camera, which provides the speed and accuracy necessary for most kinds of people photography. SLRs also let you change lenses—an important feature if you need to be versatile and and able to adapt to different locations and settings.

For the needs of a boudoir photographer, the "megapixel race" is long over. The 12 to 24 megapixels that current DSLRs provide are plenty for any typically sized prints and albums your clients will require. The most beneficial feature a modern digital SLR (DSLR) can provide boudoir photographers is low noise in high ISO settings. Often when I shoot outside the studio or on location, I encounter less than perfect lighting. A camera with high ISO capacity can save the day here, and also helps to incorporate available day or room light.

For years it was a clash of the titans, with only two manufacturers delivering serious DSLRs. This has changed—you now can choose from at least five different brands, each delivering a sufficient set of quality features and lens selections.

The Panasonic Lumix G2 is an updated model of the G1, the first Micro Four Thirds camera to enter the market. Despite its small size, it has a large sensor and a full range of camera controls, and it accepts compatible interchangeable lenses.

The Canon 5D Mark II has a 36 × 24mm full-frame sensor that provides clean images in high ISO settings, and its high resolution of up to 21 megapixels allows for double-side spreads even in large albums to be sharp and detailed.

Of course you are not limited to using DSLR, and if you would rather shoot on film or want to use medium-format cameras, this is totally fine. Using a different medium or camera might even give you an edge and make you stand out. Just be aware that film and most medium-format cameras will raise your light requirements.

To me a big advantage of digital cameras is that I can show my models some shots right away. After all, you are usually not dealing with professionals, and they might be very nervous or self-conscious. Showing them how gorgeous they look easily changes this and helps encourage them to really go for it.

There is still a debate going on whether bigger, so-called full frame (FF) sensors that have the same size as 35mm film (36×24mm) are better than the smaller APS-type sensors. Considering that a wide array of lenses are available for both types, the advantage for full-frame in image quality is marginal. The larger sensors potentially have an edge when it comes to low noise in high ISO settings, but technology is advancing fast. However, I do like the considerably larger viewfinder image in some full-frame cameras. Also, the slightly shallower depth of field due to longer focal length with FF sensors can be an advantage for boudoir photography.

Tools of the trade: lenses

It's an old wisdom: lenses make the picture, not the camera. In boudoir photography, often shallow depth of field and a soft, blurred-out background is desirable, so some lenses are especially suited. Higher-end, professional-grade lenses with a fixed aperture ($f/2.8$ and bigger) and especially prime lenses shine here.

OR MOST BOUDOIR WORK you will use focal lengths in the wide to medium telephoto range (24–135mm on a full-frame 35mm sensor), but sometimes, when there is not much room where you shoot, even shorter focal lengths may be necessary. I sometimes end up using a 16–35mm lens. Always be aware that severe distortions can result from using these shorter focal lengths, which might not be very flattering for your model. These distortions are a result of your distance to the subject, so when you take a close-up portrait of just the face it is better to back off and use a slightly longer focal length (85–135mm) than going really close with a 35mm lens.

One versatile all-round lens, like a 24–105mm or similar, can be a great starter lens and a good backup once you have a larger collection of lenses. There is always the question of whether to use zoom lenses or primes; this depends on what other styles of photography you do. If you mainly photograph portraits, then you might choose to go with primes. They are light and sharp, and usually come with very large apertures like $f/1.4$ or $f/1.2$. If you also shoot weddings, for instance, then you might settle on zooms for their versatility. But you can always mix—I do.

For the smaller, APS-sized sensors, shorter focal lengths are used to achieve the same field of view at a given distance to the subject. Every camera manufacturer and third-party lens maker has a lineup that is tailored to the smaller sensors. The selection of focal lengths in primes is more geared toward FF sensors with most brands. This is prevalent in the wide-angle range.

PRO TIP

Protect your lenses! Either leave the lens hood on or use a clear protective or UV filter. If these break, they are easy and cheap to replace. If your front element gets damaged, it is a pricey repair. Also, never travel with a lens mounted on the camera, especially not a long lens. Bangs and vibrations can de-adjust the camera's lens mount, which results in misalignment and losing focus.

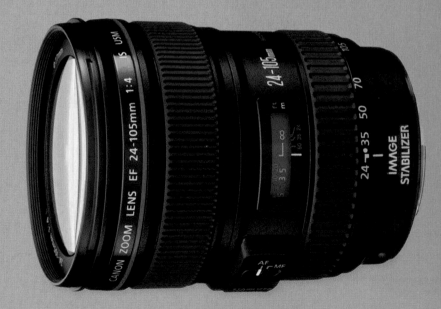

Canon's 24–105mm f/4 LIS USM lens is a classic.

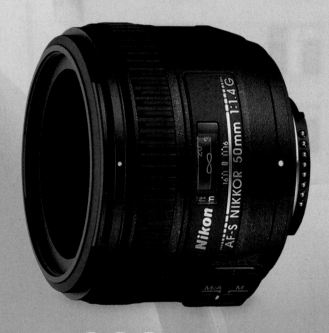

Nikon's new Nikkor 50mm f/1.4 G AF-S lens is a reasonably priced option.

It is very important to learn each lens's characteristics. The more confidently you choose a lens for a given task, the better it will serve your style. Be aware of the challenges: when shooting wide open at ƒ/1.4, your in-focus plane is as thin as a razor blade; when you use a very wide-angle lens, distortions will arise; and when you photograph from the distance with a long lens, faces can seem flat.

Image stabilization is a feature that some lenses provide (some manufacturers incorporate the image stabilization in the camera and thus there is no need for stabilized lenses). Although image stabilization can't help you with motion blur caused by your model when shooting with longer shutter speeds, it can dramatically improve image sharpness with longer focal lengths shot handheld in low light. Experiment to find the limits of stabilization and your own hand-holding skills.

At every boudoir shoot I also take some photos of details, accessories, and props: shoes, jewelry, some select lingerie pieces, or even a cute little pillow in the room. For this I have a macro lens with image stabilization—what a great tool! Macro lenses are super sharp and let you show details in small pieces and in the structure of fabric or jewelry. If chosen in a longer focal length (around 100mm for a FF camera), they also make a great portrait prime.

Lastly, there are some lenses that provide a special look, like tilt/shift lenses that can enhance or limit the depth of field significantly. Such lenses might be a welcome addition to an already complete range of lenses.

Tools of the trade: accessories

Boudoir photography can be done with the simplest setup: light from a window, and a bed, chair, or doorway. It can also get much more elaborate, with lights, modifiers, reflectors, fans, and more. However, the one accessory that is just as important as your camera gear is your computer.

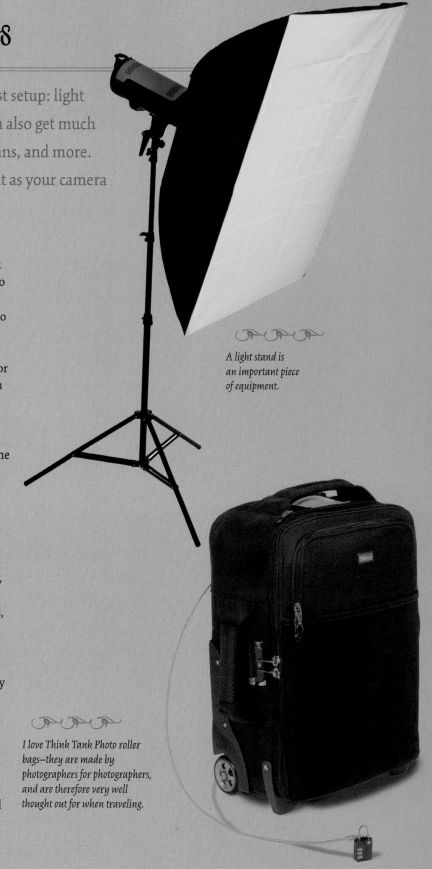

A light stand is an important piece of equipment.

Like all beauty photography, boudoir photography involves at least a minimum of retouching, and even if you work in studio and "get it right in-camera," a computer is a necessary tool to complete the images. I always make sure that the pictures my clients get to see the first time are retouched at least enough for the women to like them.

Lights, even the most basic ones, will broaden the range of environments you can work in. In many cases one single video light or flash is all you need. A fan can bring motion. Backgrounds help when you need that clean fashion look, and mirrors can even be lighting accessories as well as props.

Once the shoot is under way it can happen that I come to a point where I say, "what now?" That's when my cheat sheets—be it magazine tear outs, little prints, or even images on my cell phone or iPod—can get me going again. I might even take a look at them with my model.

Do you need a tripod for boudoir photography? Usually not—moving around your subject is the key to getting a great variety of images, and a tripod would just be in your way.

Speaking of moving around easily, if you work outside the studio you might want to have bags with you that make life on the road easy, not just in terms of your camera gear, but also any other things that you plan on bringing to the shoot: lingerie pieces, jewelry, accessories, little props. Rolling bags and suitcases are a perfect choice. For my cameras and lights I have special rollers that protect and organize; for everything else a small- to medium-sized suitcase works well. When you travel, never leave your lenses on the cameras, even though it may seem convenient to do so. Longer lenses in particular can put significant pressure on the camera's lens mount when your case goes over bumps or is being thrown into the trunk of a taxi. A loss of focus and an expensive repair can be the result.

If you use lights, you need light stands. They can also be useful for holding a reflector when you don't have an assistant with you. In the studio, sturdiness and durability are desirable; on the road weight and

I love Think Tank Photo roller bags—they are made by photographers for photographers, and are therefore very well thought out for when traveling.

size are of more concern. There are some light stands that fold up very small and fit in smaller bags, but never sacrifice stability and safety to lighten the weight. If you use strobes or hot lights, it makes sense to carry at least one extension cord; the ones with a little power strip with three or four outlets on one end are very convenient.

Cables are always a hassle, however, especially when working in smaller spaces and with models who are not professionals. There is the risk of cables getting in the way or even tripping over them. This can damage lights, room inventory, or even the health of anybody on site. That's why I use radio triggers for strobes and small flashes to reduce cables to a minimum. Triggers come in all kinds and flavors, from simple triggers for a few dollars to elaborate systems that support TTL metering and more. For a relatively controlled environment like a boudoir shoot, even the simplest ones can do.

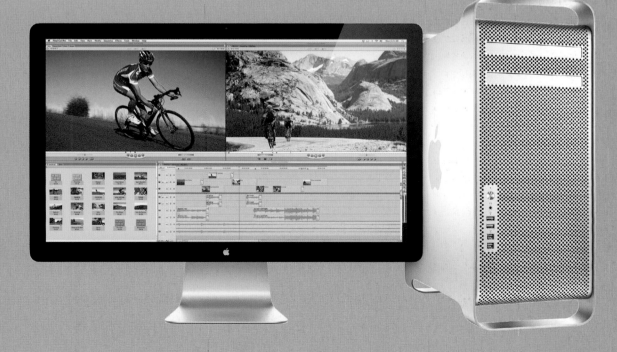

PRO TIP

Little things can ease your work, like bags and pouches to keep equipment in order or help you change a lens fast without running back and forth. I have pouches for memory cards and cases for AA batteries that I might bring for my flashes and radio triggers. Also, clamps, duct tape, a permanent marker, a little tool set, and a first-aid kit don't take up much space—but when you need them, you really need them.

A reliable and efficient computer system is essential to prevent losing important work. I use an Apple Mac Pro.

Pre-Production

PREPARATION IS EVERYTHING. If you do your homework and try to get everything arranged well before the shoot, both you and your model will experience a relaxed session. Focusing completely on her and making sure she is comfortable will get you the best pictures.

Obtaining locations

Much boudoir photography is done on location. Whether it is your own home, your model's home, or a hotel in another city, shooting in different locations not only provides variety but also allows you to offer different styles and themes.

IN MANY CASES it is advisable to be sensitive and discreet—some locations might have objections that arise from a false impression of what you are doing. In privately owned locations in particular, the manager might want to know what exactly is going on. When they hear "photo shoot," many places fear that you will arrive with a whole entourage and a truckload of equipment, which is typical for a commercial shoot. I head off their fears by calling it a "fashion or portrait shoot for a private client"; this will usually put any doubts to rest. Larger hotels usually don't care what you are doing as long as you stay in your room.

If you are working outside of your studio, it is critical to develop a variety of locations that you can use. Make a list and start scouting out all the places that you think might work. Besides the obvious—hotels—there are bed and breakfasts, little inns, apartments or penthouses of somebody you might know, and so on.

Sometimes a trade can help you get your foot in the door, since many commercial locations would love to have better photographs for advertising use.

In hotels it is good practice to try to get a day rate, which can be considerably lower than a full night's fee. If you have a room booked on a day rate, make sure that you leave the room as you found it or you run the risk of being charged for a full night.

When I look at potential rooms to be used as a location, I look for how much space I will have, how the light is (I try to figure out how the light will be at the time I am likely to shoot), and I look for usable background outside the window. Most likely a higher level provides a better view and more light. Being up higher can also shield you from onlookers or even give you the possibility of using a balcony undisturbed.

Sometimes your model may suggest a place where you have never been, or you may need to travel to your shoot. In those cases you may not have a chance to look at the location first, but online pictures or Google Street View can give you an impression so you can prepare accordingly. The same is true if you need to book a location out of town. Hotel booking and travel websites as well as the location's own website may show images that can be of help—but don't be fooled! Many places show images that give the impression of rooms being large and of great views outside the windows. The reality, however, can be a disappointment, and you just need to make the best of it.

In many cases, returning to a certain location frequently is unavoidable. To stay inspired, I try to do things differently from time to time. I rearrange furniture, set up my lighting differently, or shoot at a completely different time of day (day versus night shoot). Incorporating a different theme can also keep things exciting.

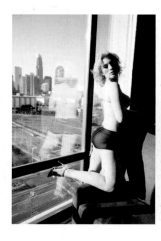
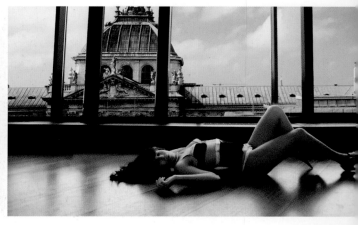

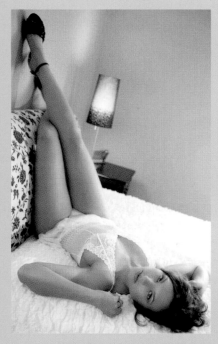

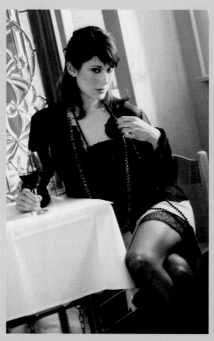

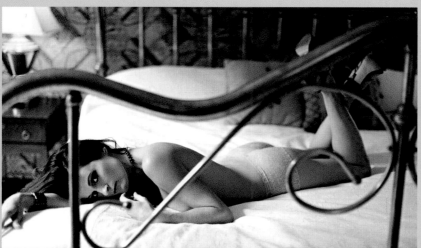

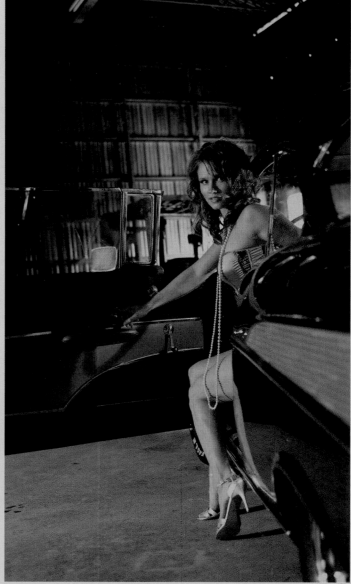

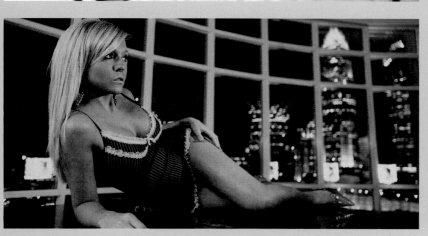

LEFT: *Finding locations with great views can make for some spectacular shots.*

TOP AND CENTER LEFT: *The client's home is another good option for boudoir.*

TOP CENTER: *This image was taken at a restaurant that had some cool elements and was great for boudoir.*

ABOVE: *The location does not need to be a typical place. It can be a theme that your subject would like to incorporate, such as a car shop.*

Hair and makeup

When you're planning a shoot you can, budget permitting, choose between having a professional stylist and makeup artist on hand, or rely on the subject's own makeup bag. Making that decision will affect how things go and what you can achieve in a day, so plan ahead.

ASKING YOUR CLIENT to prepare her own hair and makeup can mean less time for you on location but more time in post-production. A professional stylist can make a client look glamorous, and usually have access to more dramatic makeup, fake lashes, and hair extensions to give the client a more sultry look. Professionals will also be skilled in covering imperfections that may be more visible with regular makeup application. Better makeup means better shots in-camera and less time in post-production. A professional makeup artist has an artistic eye and knows exactly what colors and techniques are needed to enhance the client's best features. A good makeup artist will also assess the wardrobe for the shoot to determine how bold or creative the client's look should be.

Whether you are shooting in studio or on location, if the stylist is coming to your client to get her ready, you will also spend extra time waiting for the stylist to do his or her magic. I usually take that time to do a wardrobe consultation with the client about what she will wear for the shoot. If you want to limit your waiting time you could have the client go to the stylist first and then meet you in the studio or on location. Some stylists will offer to do a consultation with the client before the day of the shoot. This way they can decide the best makeup choices for the client and maybe practice which hairstyle works best for the look the client wants to achieve in her images.

> **PRO TIP**
>
> *Finding a set stylist to work with on a regular basis can be challenging but rewarding once you find the right person. You can include the stylist in your packages, and an option without the stylist in case the client has her own or is more comfortable doing her own hair and makeup. You can do a test shoot with most stylists to see if they fit your needs. This is also great for portfolio building if you are just starting out. Contact a local beauty salon for recommendations.*
>
> *Looking online for commercial stylists or even a bridal hair and makeup artist is a great way to find someone to work with. How to structure the stylist into your package prices will depend on how you sell the stylist.*

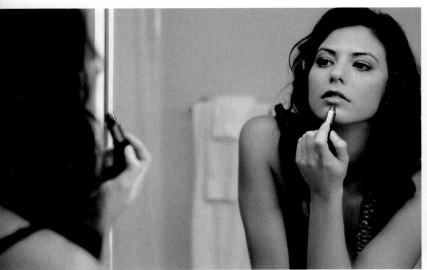
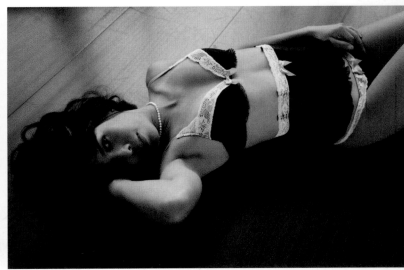

If you decide that you'd like to shoot a number of different looks, a stylist will be able to help you quickly and easily switch, adding to the number of different looks you can achieve in any given timeframe. An on-set stylist can also help the client feel pampered and that she is receiving a more luxurious session. "Pampering" might sound frivolous, but when you're not working with an experienced model anything that helps the subject feel relaxed is invaluable. If the stylist stays throughout the session he or she may also do touch-ups or redo the look to give you more versatile images throughout the session.

A good set stylist may also help you with props and posing. Props can be not only clothing but also items such as hair extensions, fake lashes, bra extenders, and lifts. These things can be used to enhance the client's look without having to do it later in post-processing. From a photographer's perspective there are other advantages too. Once you're shooting, the subject is out of the stylist's hands, so he or she is free to act as an assistant, holding reflectors, making quick tweaks to the set, and perhaps even adjusting the lighting depending on his or her degree of experience. Not only is this cheaper than having a separate photographer's assistant, but it also creates a continuity for the client, reducing the number of people she encounters when she's feeling exposed.

Stylists who can do both hair and makeup may be hard to find but are definitely worth looking for. Having one stylist for hair and another for makeup at the shoot can be overwhelming for the client, never mind the additional room and time requirements needed. The cost for two stylists will most likely be higher as well.

Stylist prices can vary, depending on the service they are providing and how much time they will stay at the shoot. Be sure to discuss this prior to the shoot day. You may include the stylist in your base package for the client, or you can have the client pay the stylist directly. I have found that for me it works best to include the stylist. I use this as a selling point when booking a session.

FAR LEFT: *The subject applying lipstick in a mirror can make an alluring photo.*

LEFT: *Professional hair and makeup can help the client to feel more confident, and this will then show in the images.*

RIGHT AND BELOW: *Having the client's hair and makeup done on location before the shoot can help her feel more glamorous and pampered.*

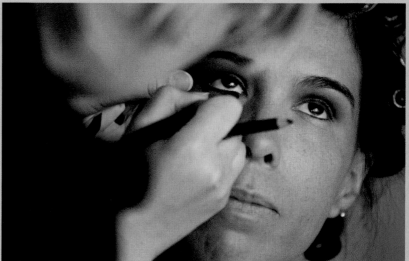

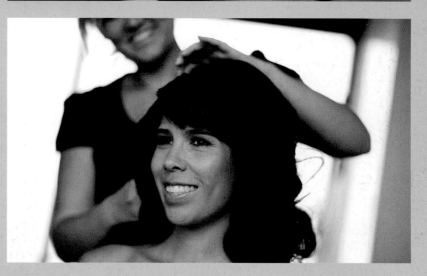

Wardrobe

Whether you supply items for your client or have her bring her own personal items, wardrobe is key for a great session. If you have the client bring her own wardrobe, make a suggestion list of the items you want her to bring.

START WITH THE OBVIOUS, such as bra and panty sets, lingerie, and nighties, and suggest things that the client may not think of, such as a see-through blouse or an evening gown. Everyday clothes can be sexy too; a half-buttoned pair of jeans can make for a great photograph. Be creative when making your list, and don't forget to have the client include items that belong to her significant other.

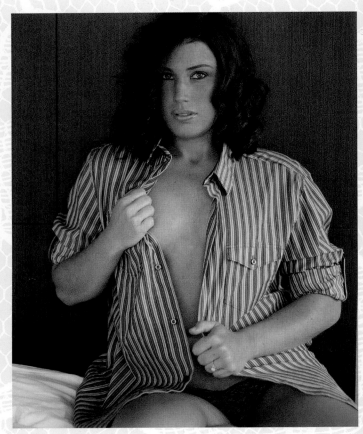

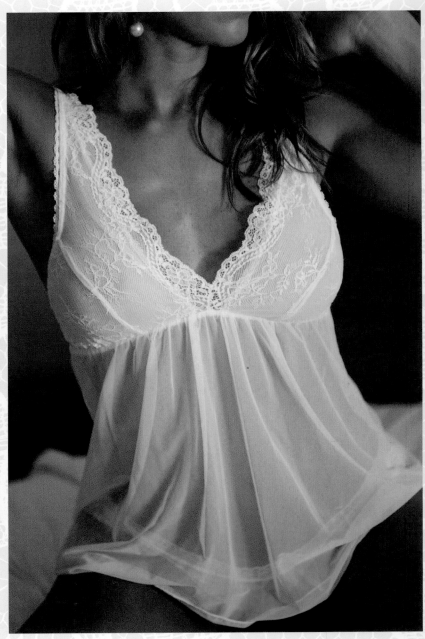

ABOVE: *Have the subject bring something from her significant other's wardrobe for one or two images.*

RIGHT: *A sexy nightie is perfect for boudoir.*

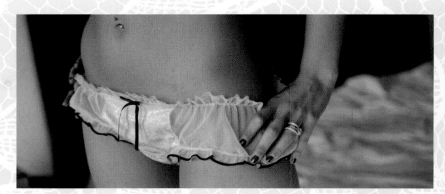

If you decide to supply items for your clients, you will need to buy several items in many sizes. Some photographers supply items that can be cleaned and worn again, but not anything too personal, such as undergarments. Items supplied might be things such as corsets, garter belts, bustiers, fishnet stockings, waist cinches, and jewelry. Think of the session as a fashion shoot. By having different outfit changes you can transform your subject from modest maiden to sexy diva.

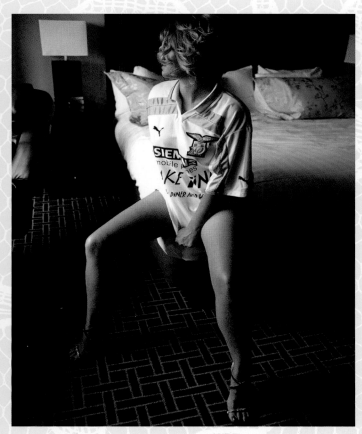

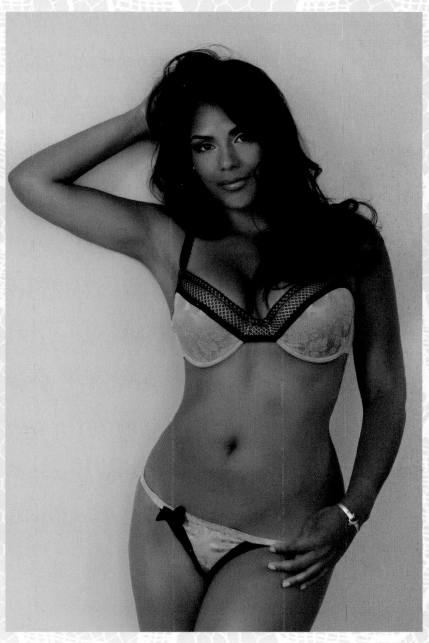

ABOVE: *His sports jersey is another popular item clients bring.*

RIGHT: *Matching bra and panty sets are a must, but non-matching is okay too.*

Have a wardrobe consultation with the client beforehand or on the day of the shoot. At this time you can choose items that will work best for the client's body type and create the style that best suits her. Clothing can also conceal problem areas such as varicose veins or stretch marks. Clothing such as a bustier can also tuck in the tummy and push up the breasts. Bustiers look great on all sizes of women and can help conceal some imperfections. If you have a client who has an area or body part she wants to conceal, give her ideas of what clothing to bring. If a client does not love her legs, you may suggest thigh-highs or stockings, or if the client does not love her hips suggest longer nighties and/or slips. Be creative with clothing and find even everyday wear to suggest.

 PRO TIP

Add a few pieces of jewelry to your collection that may be worn by the client during the shoot. Jewelry can take the focus away from areas you want to conceal.

BELOW: *Service clothing is popular for women with a significant other in the military.*

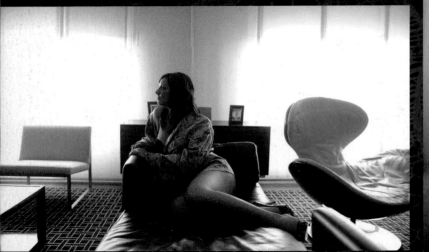

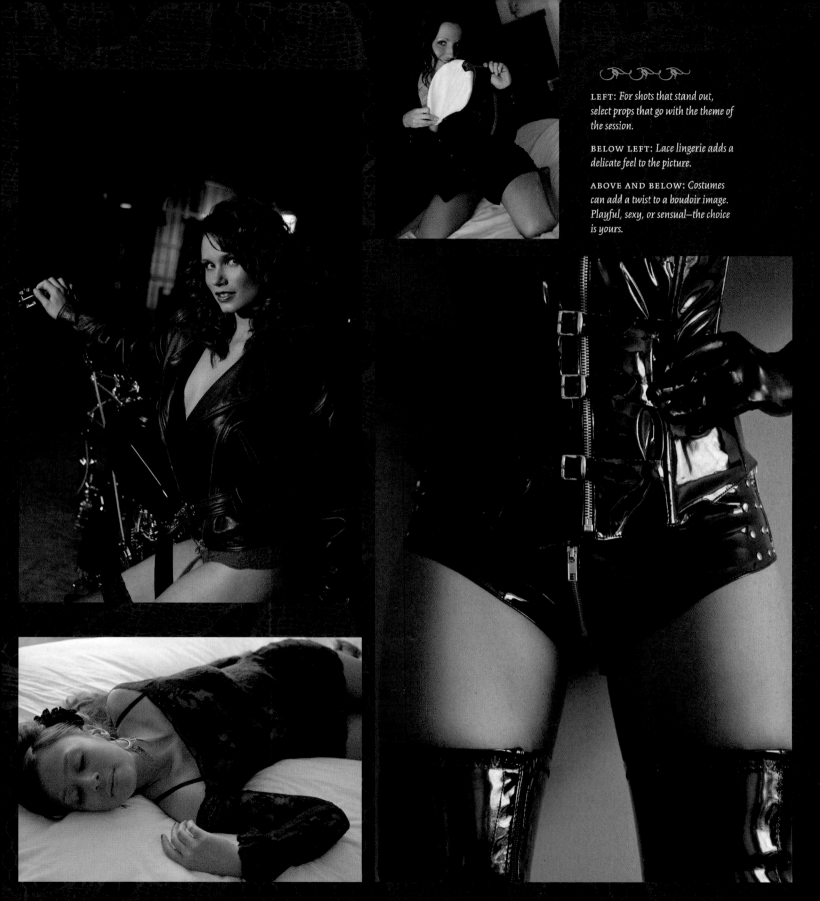

LEFT: *For shots that stand out, select props that go with the theme of the session.*

BELOW LEFT: *Lace lingerie adds a delicate feel to the picture.*

ABOVE AND BELOW: *Costumes can add a twist to a boudoir image. Playful, sexy, or sensual—the choice is yours.*

Before and after

Hiring a stylist for the shoot can enhance the client's experience and help eliminate more Photoshop retouching. You can enhance the client's enjoyment of the shoot still further by recording her dramatic transformation.

IF YOU USE A STYLIST for the shoot, be sure to take photos of the client before and after to use for your and the stylist's portfolios, if the client gives you permission to use the images. This is a good way to show potential clients how glamorous the shoot can be, and also the difference between them doing their own styling and having a professional do it for them. If you hire the stylist, be sure to find out how he or she wants the client to come to the shoot. My stylist prefers clients to come with clean, dry hair so she can get started right away. Some stylists prefer unwashed hair from the day before. My stylist also asks that the client moisturize her face and have any facial grooming, such as eyebrow or facial waxing, done prior to the shoot.

Before-and-after photos are a great way to show the client's transition from everyday ordinary to super sexy.

before

PRO TIP

Be sure to include the before shots in the clients' proofs so they can see firsthand their own transformation. For many women, the makeup and the shoot reveals them at their most beautiful, and they love to see how far they were transformed on the day.

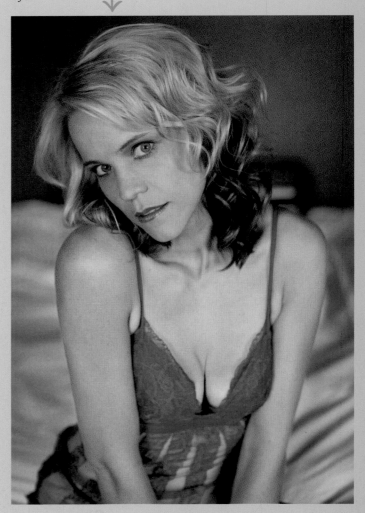

after

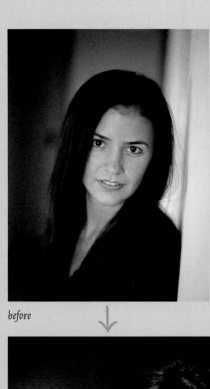

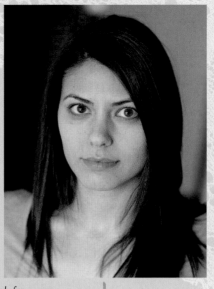

before

before

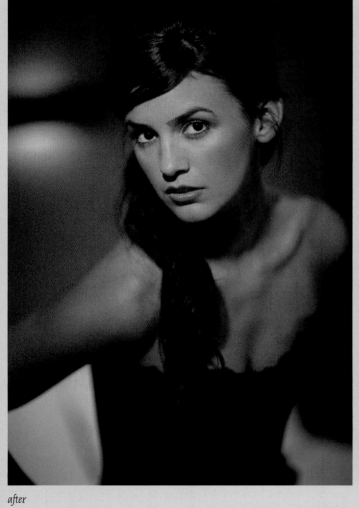

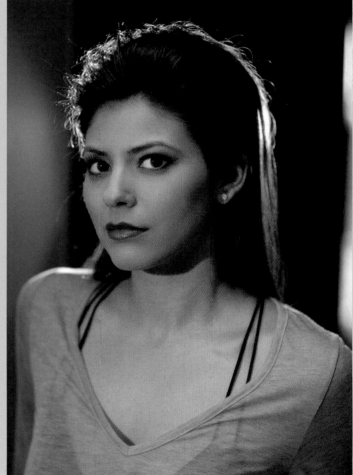

after

after

Accessories and props

Props can make for fun photos, increase variety in the images, and set the mood and tone for the shoot. They can also help with posing and give the model something to do with her hands. If she is a little uncomfortable, giving her a prop to work with can help her relax.

DEPENDING ON WHICH PROPS you include and how you use them, props and accessories can be used to make images look more natural and not too posed. A prop can be just about anything, and can be something the client wants to incorporate or one of the items you keep on hand.

Be sure to discuss ideas to use for props with the client beforehand. Most of the time the client will have her own ideas on what to bring—for example, a cowboy hat and boots, or a football or team jersey. Props and accessories for boudoir photography can be anything the imagination can come up with, from jewelry to Mardi Gras masks, and allow you to change the look of the setting.

Whenever you are out, look around for what could be used as a prop or accessory. I also spend considerable time browsing the Internet for ideas. The websites eBay (www.ebay.com) and Etsy (www.etsy.com) are great resources, and I also find IKEA to be a great place for small props like footstools with changeable covers and much more. Also, consignment stores, flea markets, and yard sales can yield little gems that will make your shoots unique. It's second nature to me now to look for inspirational objects whether I'm traveling or close to home.

 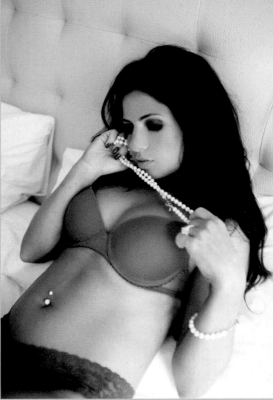 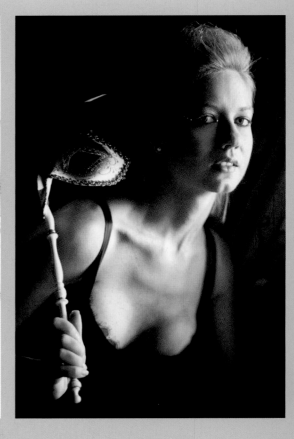

OPPOSITE LEFT: *Garter belts look good with or without stockings.*

OPPOSITE CENTER: *Necklaces make for great props. They can be a great way for the subject to use her hands in a pose.*

OPPOSITE RIGHT: *Mardi Gras masks can add drama.*

RIGHT: *Shoes are a must in any boudoir session.*

BELOW: *A spare pair of panties can be used as a prop to create the illusion of clothes coming off.*

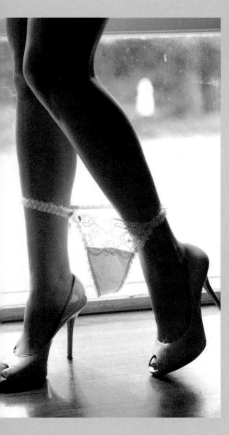

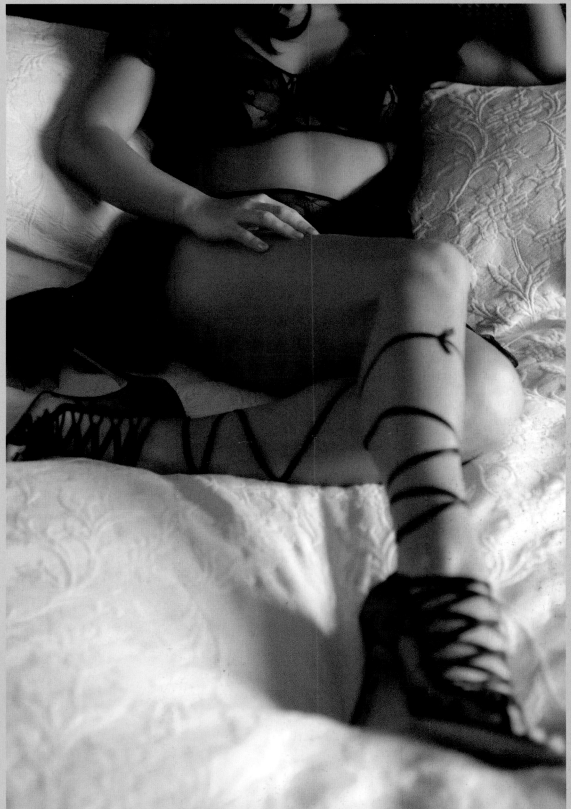

Quality of light

Light is what creates a picture, and this is especially true for boudoir photography. Light sets the mood, and good lighting can enhance your model's features and hide flaws. If your lighting and posing are good, your boudoir photography will be great!

AS WITH ANY OTHER STYLES of photography, magazines and movies can be great inspiration. Fashion photography is an amazing resource for light and mood. If you see something that looks great, try to find out how it was done. Paintings—especially those of the great Dutch masters—also demonstrate great use of light and mood. There is no substitute for constantly experimenting and practicing. Widen your horizons, try something new to see how it looks, and don't be afraid of bending the rules.

"Quality of light" expresses how light can improve and flatter a scene. Terms like "soft" and "harsh" light are used. Light that produces soft shadow edges is considered to be flattering, or "quality light."

Soft light is achieved by a light source that is large in comparison to the subject. That said, a light source that is 5 feet tall may be small in comparison to your subject if the light source is 20 feet away. The direction of light plays a big role. Light produces shadows, and any light that does not come exactly from where the camera is will produce shadows that the camera will see. The result is depth and three-dimensionality.

The best example of what is considered "bad" light is the flash of a little point-and-shoot camera. No matter how close you get, it's small, and it's coming directly from the front. We have all seen it, and it really doesn't look great.

Start seeing everything around you as a potential tool to enlarge your light sources. Everything you can bounce light off will do the trick, including walls, ceilings, a piece of paper, or someone wearing a white shirt or dress. Enlarging a light source will always cost you light intensity. Be aware of this, as well as of the fact that moving a light away from your subject (often erroneously done to reduce power), will also reduce the light's effective size.

This was taken using natural window light.

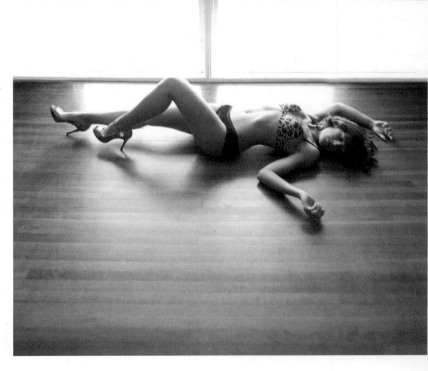

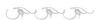
Adding small, point-like light sources to your lighting is a great way to bring a sparkle into hair, eyes, and jewelry. If you are using mostly large light sources in a shoot, things can tend to look a bit flat, missing that glamorous snap. Pointing a small video light or a little flashgun at those sections can bring back the "bling."

RIGHT AND BELOW RIGHT: *Experiment with using different light—don't be afraid to try something different.*

Shadow edges in soft light can be so smooth that they disappear altogether. The result is a less pronounced structure, which can hide imperfections, but also a relatively low three-dimensionality. The emphasis on bright, highly exposed or dark, lowly exposed parts in an image can give photos a very strong expression. Images with mostly bright areas are called high-key; images with mostly dark sections low-key. This can be achieved either by having predominantly light- or dark-colored elements in the picture, or by deliberately over- or underexposing. Look at advertisements and movies and you will see that this technique is widely used. It can contribute strongly to the mood of boudoir photography.

Another aspect of light quality is the color spectrum that a light source offers. You most likely will not have any problems with this if you shoot in the studio or exclusively use bright daylight, halogen light, and flash. If, however, you want to work in locations with fluorescent lights (like some hallways), or with strongly dimmed tungsten lights, you will be dealing with light sources that have an incomplete color spectrum, and problems with skin tones will result. The same is true for daylight, which, when encountered shortly before sunrise and shortly after sundown, will give a strong blue cast. If large parts of the light spectrum are missing, it is very hard, if not impossible, to restore them in post-production. Of course, you may use the resulting color cast as a creative attribute.

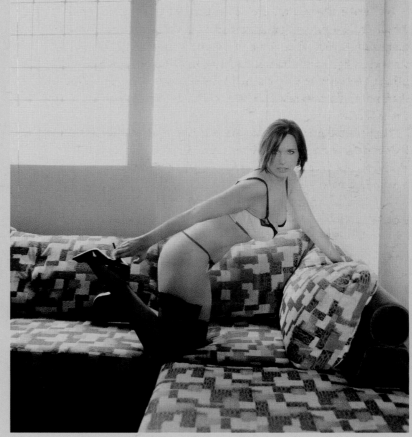

Natural light

Natural daylight is wonderful. If it's there, use it. The three main variations it comes in are direct (sunlight), diffused (overcast day), and open shadow (the reflected light that comes from blue skies on a sunny day).

Direct sunlight casts harsh shadows and produces vibrant, saturated colors. Don't be afraid of it! It can look very dramatic, especially when it is coming from a different direction than the camera. Also, filling the deep shadows can take the edge off this kind of light (more on this later).

Take care always to shoot variations, as direct sunlight can exaggerate unwanted features, and always look after your model to check that the sun isn't blinding her, causing her to squint. I always ask my model not to look directly at the sun.

Diffused daylight and open shadow produce soft or sometimes barely any shadows. This can be very flattering; it smooths out skin irregularities and softly models your subject. If I encounter a situation in which the image tends to get too flat from such lighting, I add in a light or have the model stand close to a darker area to bring back three-dimensionality.

Diffused daylight that comes through a smaller window or door is very directional. It can look dramatic, producing a pronounced play of light and shadows, while at the same time the shadow edges are beautifully soft.

Work with the different colors that natural light creates throughout the day: from orange morning light to crystal-clear direct sunlight, from blue light in open shadow or shortly before nightfall, to deep red light at dusk. However, be aware that light with a strong bluish cast (open shadow and before nightfall) cannot be fully corrected for pleasing skin tones, even when you are shooting in raw. This can be countered by adding some artificial light.

Whenever you are working with daylight, a reflector is a great and simple tool. Its usefulness is endless, from slightly brightening shadow sections to using the reflected light as a main light. Foldable reflectors are the most common and versatile ones. However, a white panel or piece of fabric or even a white wall can be used as a reflector. It is

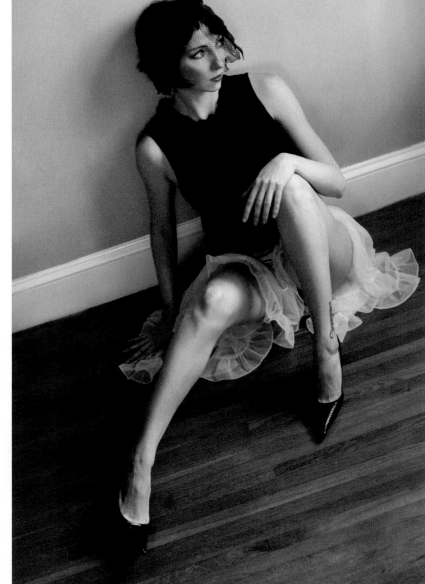

All of these images were taken using natural window light.

always better to use a larger reflector than a smaller one. A large reflector can be folded away, whereas you cannot enlarge a small reflector.

When you are working exclusively with daylight, be sensitive to situations where its direction may yield less than desirable results: in particular, light coming more from above than from the front or side can produce dark eyes and an overly bright top of the head. Filling with a reflector, shading with a diffuser, or turning the face more toward the light are possible solutions to these problems.

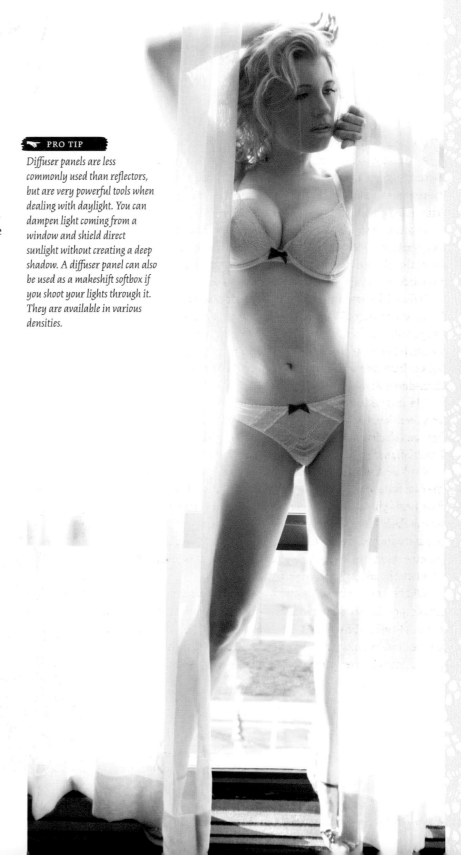

Studio lighting

Setting up lights should not just be rote and mechanical. Lighting is another creative tool that can drastically enhance your boudoir shoots when mastered. It will also give you the confidence and ability to achive fabulous results in all locations and scenarios.

STUDIO LIGHTS HELP YOU LIGHT your subject in endless different ways. You gain control by choosing the right lights for a given job and become more independent from conditions that could make your work difficult or even impossible.

The two main categories are continuous lights and flash. When you work with continuous lights you need to watch your exposures just as when working in daylight. Motion blur and camera shake are a danger when shooting with slow shutter speeds. The current generation of DSLRs perform very well at high ISO settings and help you keep sufficient shutter speeds, even when light levels are low.

Familiarize yourself with the "rule of square" when lighting. It is a principle that helps immensely when dealing with light: the energy (brightness) of a light decreases with the square of the distance. Say you have a light 6 feet from your subject; if you move the light to 12 feet from the subject (two times the distance), only 1/4 of the brightness will hit your subject. This means that differences in close distance matter drastically; especially when shooting in small spaces, the effect is very prevalent.

This effect can also be observed in light fall-off. If you have a light very close to your subject, parts that are farther away from the light will be considerably darker. Having the light farther off will give more homogeneous lighting. In boudoir photography, where mood is just as important as even lighting, these principles play a big role.

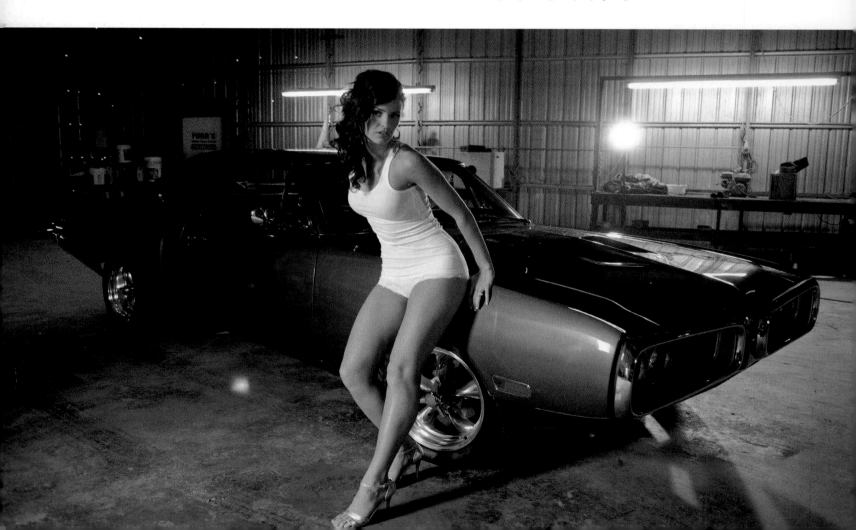

Hot Lights

This category includes most lights besides flash—even your studio strobe's modeling light. Most hot lights have a rather yellow, warm tone (2,500–3,500 K). You can use this for a warm mood, or eliminate it by setting your camera's white balance accordingly (or by using filter gels). There is no wrong or right. A special type of hot light called HMI is daylight balanced, yielding a color temperature around 6,000 K. In the past they were very expensive, but they now are available at more affordable prices.

There are hot lights that are specifically made for use with modifiers like umbrellas and softboxes, and there are small spotlights (often referred to as "video lights"), some tiny and handheld, some larger for use with big batteries or AC power.

Examples of video lighting.

Many of the video light types provide beautiful directional light with a soft fall-off at the edge of the beam. Some can be dimmed; some can be focused. They also work very well with an umbrella.

What I appreciate most with hot lights is that they are also continuous lights. This makes it easy to adjust and compose, and to check for shadows and reflections in windows and mirrors. In addition many hot lights are very affordable. All in all they are a great way to start out learning about lighting.

A downside of hot lights is that they are, well, hot! This can become a problem in small, confined spaces, namely little hotel rooms. A new type of continuous lights is up and coming—LED lights. The good ones that provide more power and a nice beam are unfortunately still a bit pricey, but they might soon be a great alternative to "hot" lights.

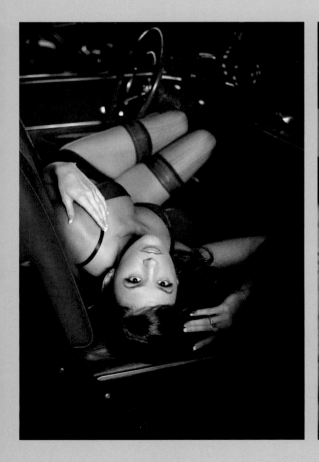
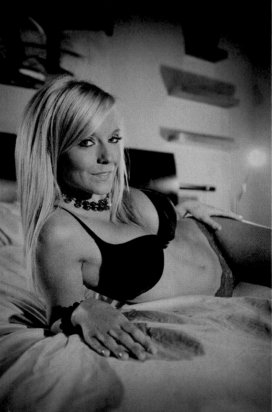
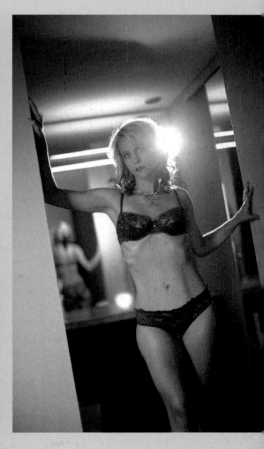

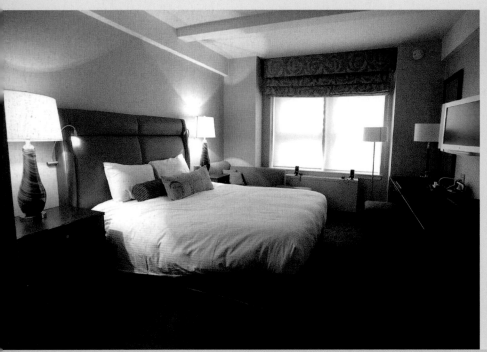

Examples of studio lighting.

Fluorescent Lights

Fluorescent lights are a small but interesting group of continuous lights, mostly for use with modifiers. It is important that photographic fluorescent bulbs are used, with a light close to daylight. Other "home use" fluorescent lights have awful color casts, and pleasing skin tones are hard to obtain with them. Most fluorescent lights are a bit bulky and thus not the best travel lights, but in studio they are a great compromise between low temperatures and the predictability of continuous lights.

Flash

Flash is an amazing tool, but unfortunately many photographers are intimidated by it and therefore lose out on what is probably the most versatile lighting tool out there.

The two main types are studio strobes and little external flash units (Nikon's Speedlights are an example). The second type has come a long way, and a host of innovative wedding and portrait photographers have discovered them as an amazing and compact lighting tool.

Besides its power (usually magnitudes higher than that of continuous lights), the most important quality of flash is that its effect on the exposure is more or less independent from shutter speed. There is a maximum shutter speed that most cameras can work with when using flash (in many cases around 1/200–1/300 sec.—check your camera's specifications), but the pop of a flash is usually much shorter than that (up to 1/40,000 sec. and shorter), so it doesn't matter if your

shutter speed is 1 second or 1/100 sec.—the full energy of the pop will reach your camera's sensor. What this means is that shutter speed solely affects continuous lights. Therefore you can easily balance any ambient light with flash.

Most times flash will be used with a modifier, since flashes are generally a rather small light source (especially the little camera flashes) and the resulting shadows will be pretty harsh. If you use camera flashes, use them off-camera, meaning on a light stand, or bounce them off a wall or ceiling. Flash directly from the camera onto your subject will look quite bad most of the time.

The cost for flash can be surprisingly low. Older or secondhand external flash units can be had for very low cost, and even simple studio strobes like the popular Alien Bee range are very affordable.

◤ PRO TIP ◢

Balancing ambient light with flash is a powerful creative tool. It is an easy way to bring in enough room light or daylight to set the scene, and then use flash either to fill shadows or as an efficient main light source. Expose for your model by setting flash power and aperture accordingly, then blend in the ambient light to your liking by setting the shutter speed. You can modify your shutter speed freely as long as you stay within the camera's shortest sync speed. If flash is your main source of light, even extremely long shutter speeds will not cause motion blur on your subject, since the extremely short flash duration "freezes" any subject motion.

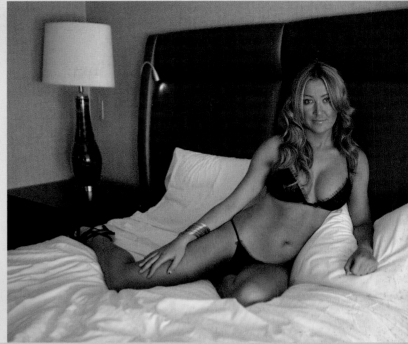

Light Modifiers

Light modifiers are used to direct the light and to enlarge the size of a light source. I have all kinds of modifiers to adjust to any given job.

Umbrellas

Umbrellas are an extremely versatile and inexpensive modifier, and they are easy to travel with. They come with white and silver linings or in white fabric to shoot through. Some are combo constructions where you can take off a black/silver or black/white back and end up with a shoot-through umbrella. Because of their low price it is easy to get several sizes, and especially when you travel having smaller ones might be obligatory.

White or silver linings affect the harshness of the light. Shoot-through umbrellas are used to get the light closer to your subject, therefore giving softer light. However, the light fall-off will be more prominent.

The biggest downside of an umbrella can be the light spill hitting ceiling and walls, especially when paired with flash. This can also reflect in windows and mirrors, making your shots look bad, so check your camera's LCD monitor and use your strobe's modeling light to make sure there are no unwanted reflections.

Softboxes/Octoboxes

The one and only purpose of softboxes and octoboxes is to enlarge the light source and therefore create softer shadows. However, softboxes confine light and thus have no light spill. I like them because I can control the light very well and get even closer to my subject than with an umbrella.

Softboxes are probably the premium light modifier. Their biggest downside, though, can be that they are more difficult to transport and they may be pretty bulky in a small room. There are some softboxes and octoboxes that can be assembled almost as easily as an umbrella. Octoboxes stand out because of their almost circular shape. They can be better when you need a light source that illuminates height and width. Striplights, a special kind of softbox, are very long and narrow. They work great for lighting a model lying on a bed, or lighting her full length while she is standing.

Grids

I love grids! They are applied to the front of a strobe and confine the light to a narrow beam which results in a spotlight effect with a smooth fall-off at the edge. Grids are usually available with wider or smaller openings, the first resulting in a larger light circle, the latter in a narrower one. Light from a gridded strobe can add a lot of mood to a boudoir shoot. Also, when used as a hair or rim light, a grid helps with concentrating the light where it needs to be.

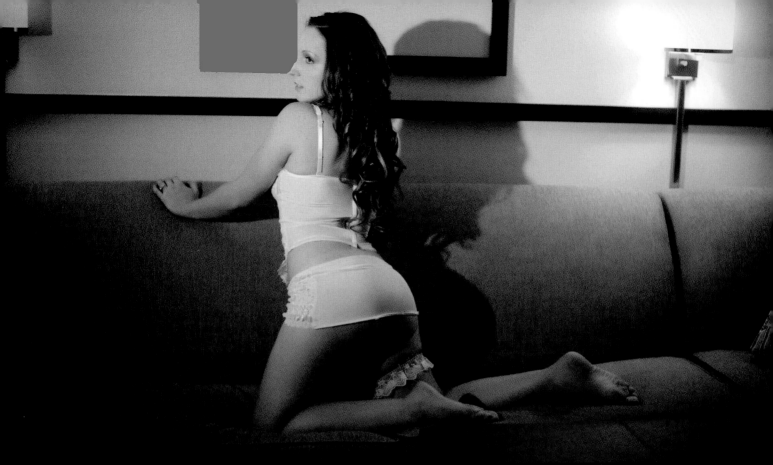

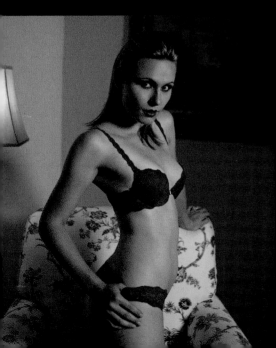

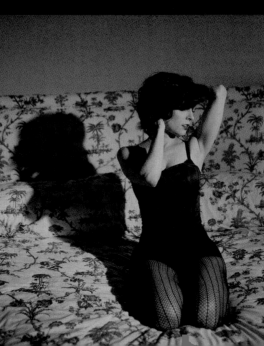

Two off-camera flashes were here used to create a natural light effect.

Reflectors

The reflector is the Swiss army knife of light modifiers. You can bounce, direct, and shield with these, and they come in all sizes and shapes. The best-known ones are the foldable reflectors, but there are also hard reflector panels, and many of them can be built from cheap materials.

Use a reflector to bring light from a window into the depths of a room, to bounce (and thus enlarge) your flash or hot light, or to shield your lens from light that causes flare, or hold it over your model to have her in the shade.

A reflector can be your main light source or it can be used as fill light to open up shadows. Many situations in which a photographer uses two lights could just as easily be handled by one light and a reflector. Reflectors come in many colors, from gold to silver to gold/silver mixes to white. Get a white/silver reflector before you dig into the more restricted use of any other kind, and watch for the appearance of skin when a silver reflector is the main light. It creates more specular reflections, and some call their light "oily." A white reflector will give smoother light; however, its reflection is also less strong.

Filter Gels

With filter gels you can either tint your lights or adjust them to other existing light sources. Digital cameras and their capability to set white balance have opened the door for easy and creative use of tinted light.

If you have only one single light source and nothing else, then you won't need gels—white balance will take care of it. If, however, you are adding to some existing lights, be it daylight or room lights, you might want to have the additional control.

Of course there are no hard and fast rules; sometimes you want to see the color difference from different light sources or even emulate it. For instance, if you shoot with ungelled flash as your main light but you want to add a warm cast as a sidelight, as if it came from a table lamp, just gel the flash that's providing the side light orange or straw.

◤ PRO TIP

Lights can be a challenge for the traveling photographer, especially if you want to bring lights that look good and give variety. In some places you might not have any AC power; if you need to fly, anything large and heavy can be a problem.

Find light stands that fold down small enough to fit in your suitcase. The good thing is that when traveling for boudoir photography you very often end up in smaller rooms anyway, so you will not need very high light stands. Just make sure that they can bear the maximum load you intend to put on them without bending and tilting.

Smaller battery-powered lights can be great when on the road. Camera flashes, even if you bring more than one, are easy to travel with. They are very versatile and give you lots of power. Also, medium-sized video lights are great. Available in battery-powered or AC-powered versions, you can use them directly or aim them into an umbrella.

Umbrellas are definitely easier to travel with than softboxes, and if you get one with a detachable outer liner, than you have a very flexible lighting tool. A folding reflector is another small and light accessory that travels easily and gives you lots of possibilities in return.

When you travel to other countries, make sure your lights will work there and that you have the correct plugs. With battery-powered lights you will not have many problems, unless you need to charge them. AC-powered lights, however, might need different light bulbs or may not work under different voltage at all.

Posing Reference

❧❧❧❧❧❧❧❧❧

BESIDES LIGHTING, posing is by far the most important tool for every boudoir photographer. Having a large repertoire of poses available yields a greater variation of photos and also enables you to correct problem zones that may occur even with slim models. Great poses will make you stand out as a capable boudoir photographer, and more clients will likely demand your services.

Introduction to posing

One thing you have to remember when working with everyday clients is that they are usually not experienced in posing for the camera, unlike a model who has much more experience striking a sexy pose.

OACHING THE CLIENT will help achieve the look you are trying to capture. Don't just tell her what you want—show her! If you are explaining a pose it is so much easier for her to understand what you want by showing her. You do not need to be a great poser yourself; if you are not, use inspirational material pulled from magazines. You may show her an image from a tear sheet that you want her to emulate and this will help her to achieve something close to the look. I usually try to put my own spin on a pose from a tear sheet to make it my own. Little adjustments can make the pose different and unique to you. Shooting the pose from different angles will also make for a different look—remember to always walk around your client and take shots from different views. This gives you variety and will make the pose look different from the tearsheet as well.

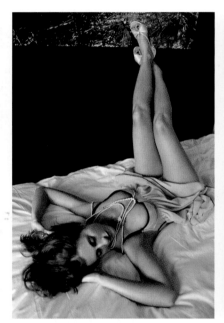

Use the headboard of the bed to showcase a subject's legs.

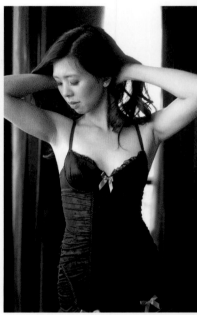

Look for pose inspiration in magazines.

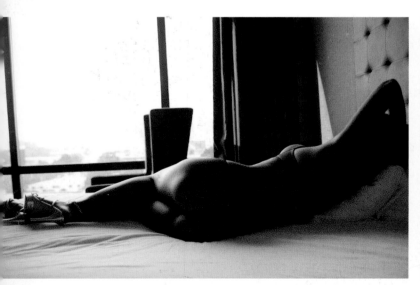

The subject's face does not always need to be shown in the image.

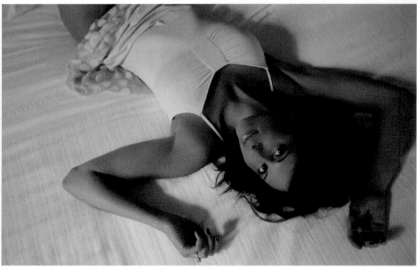

Remember to photograph the client from different angles.

*Details details details—
don't forget the details!*

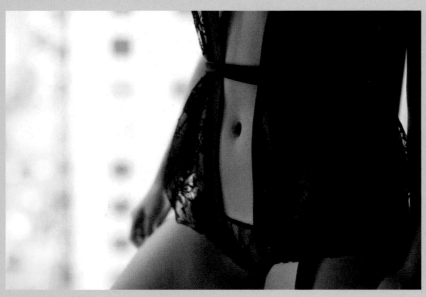

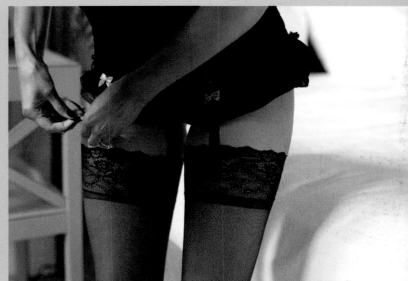

No.1

POSING INSIDE

When posing inside be sure to use the whole space, whether it is a studio, the subject's home, or a hotel suite. Don't just pick one spot and stick to it.

I guarantee you that every place has more than one spot you can use. For example, you can shoot with the model between you and the window, and then with you standing between the model and the window. You will have completely different light in each of those cases and also from any position in between. The same holds true for any other light source.

Of course, inside is easier for poses that are a bit more risqué—semi-nudes or full nudes. There are a lot of options with inside shots which we will go into next.

PRO TIP

Take some time to look around where you will be shooting. This will help you generate ideas about how to use your inside location.

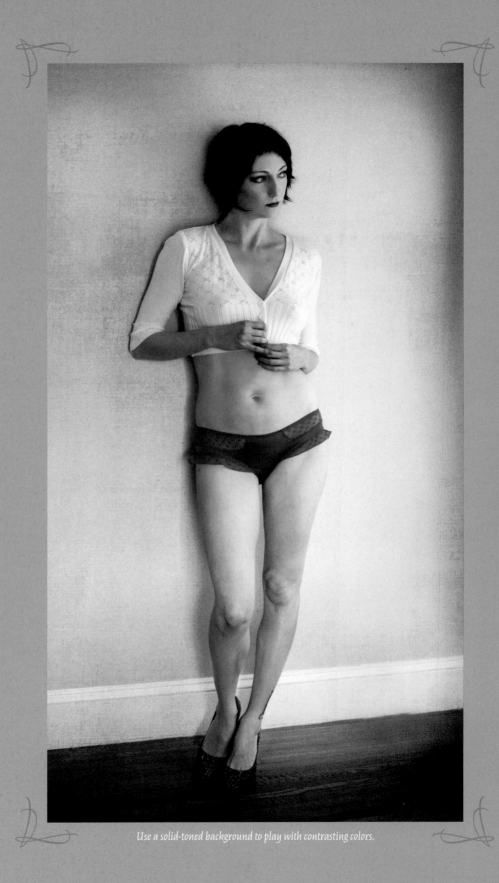

Use a solid-toned background to play with contrasting colors.

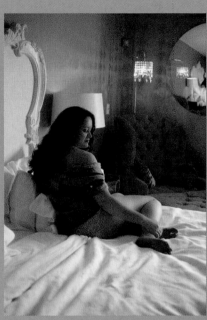

Include some of the space in your photos to add a "lived in" feel.

Showing details in the background will also give the image more of a lifestyle feel.

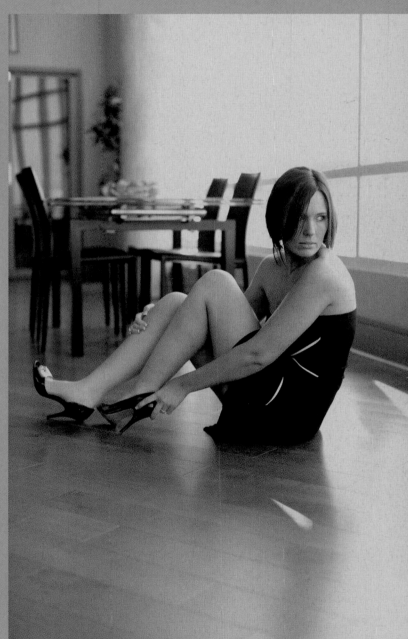

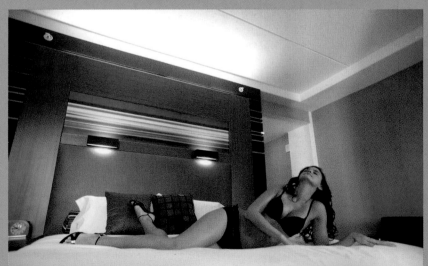

Try to show more of the room in some shots.

No area should be off-limits, including the dining room and kitchen.

No. 2

POSING
WITH
A BED

Posing with furniture is probably the easiest posing of all. There are so many poses you can base on furniture.

Take a bed, for instance. You can have the subject lie across the bed face up, or on her stomach in a sexy, cat-like stretch. You can have the subject lie half on and half off the bed. Have her put her legs up across the headboard to showcase her legs and thighs and even her shoes.

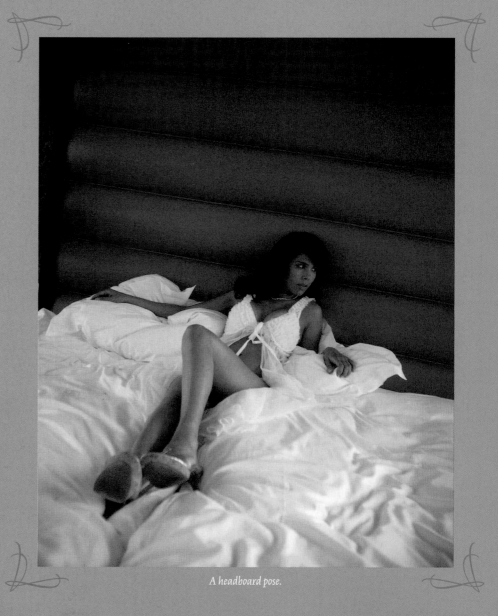

A headboard pose.

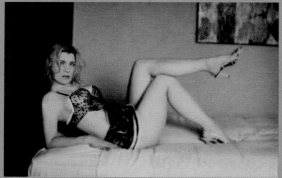

Leaning against the headboard with legs crossed, slightly pushing up on the arms.

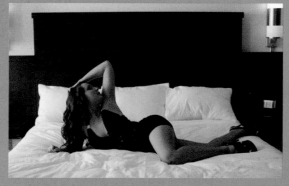

Bed pose: have the client lie on her side, draw her knee up, and hold her arm above her head.

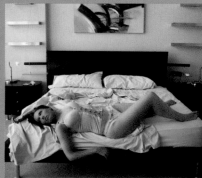

The client does not always have to be in the center of the bed.

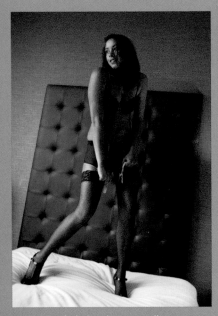

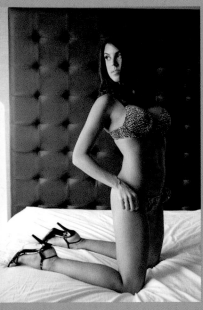

Standing on the bed works just as well!

The subject does not always need to be lying down on the bed for it to be a sexy pose.

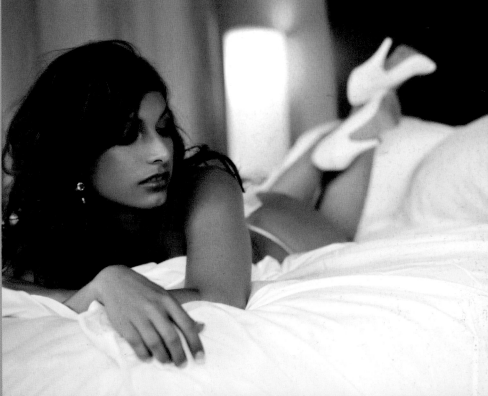

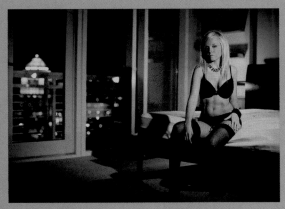

Bed poses can vary so may ways!

Beds can be used to lie on or to lean against.

POSING REFERENCE

No.3

POSING
WITH CHAIRS
AND COUCHES

Chairs and couches are great pieces of
furniture to use while posing. Clients can sit
in a sexy position, or have them perched on
top for a different view. You may also have
the client sit on the floor and use the chair as
a prop.

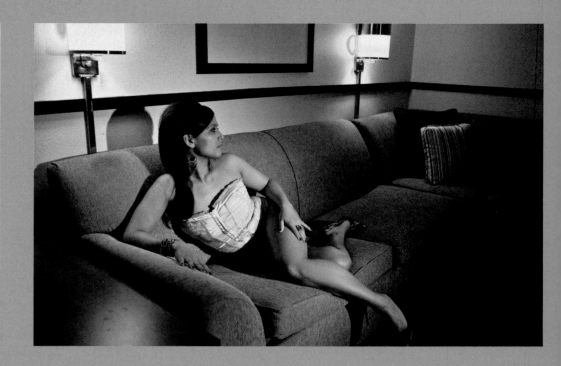

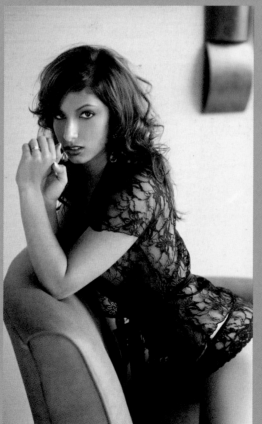

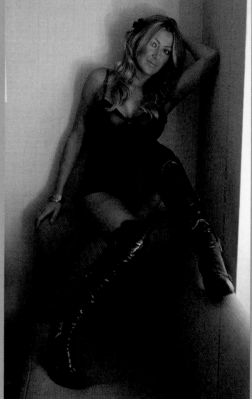

Couches can be utilized for many poses.

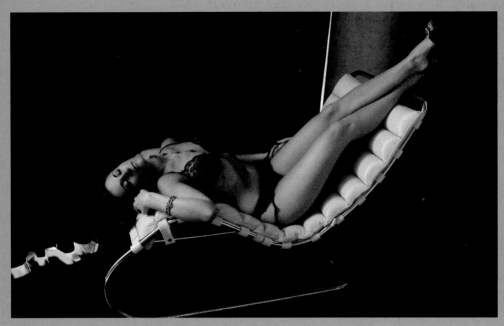

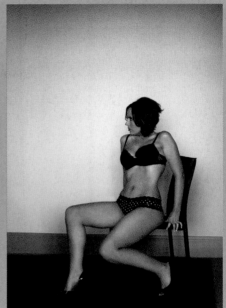

Chairs are another great posing tool.

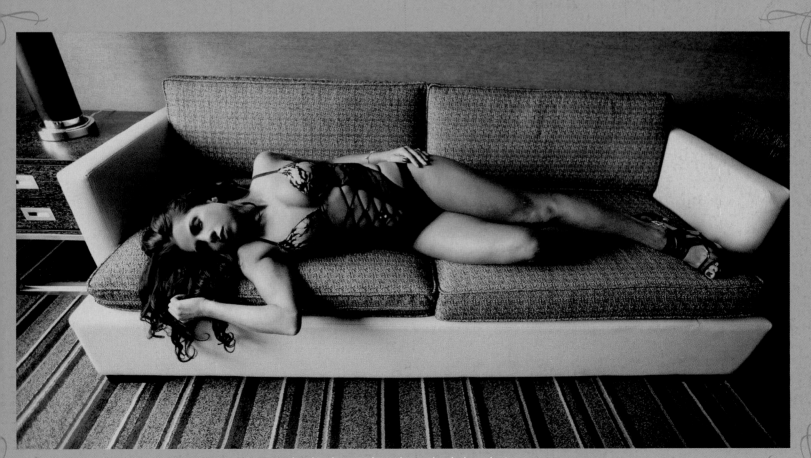

Have the subject lie across the couch in a relaxed, almost sleeping state.

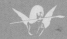

No. 4

POSING WITH OTHER FURNITURE

Almost any piece of furniture may be used to lean against for a pose. Have the subject lean her backside against the furniture and stretch her shoulders away—this will keep her from either looking overly posed or as if she is just standing there. If you have a coffee table, kitchen table, or a table that is tall enough for the client to lie across, this can make for a sexy shot. Have her stretch across with knees up and her arms resting above her head. This pose is very effective on the floor as well.

Armoires are good for the subject to lean against or to pose with.

✦ PRO TIP

I love the warm shine of table lamps, so if you have a lamp on the bedside table or any furniture in the shot, turn it on! Even better, if your model stands close to the lamp it can serve as an additional light, giving parts of her face a beautiful warm glow.

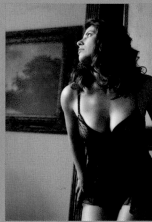

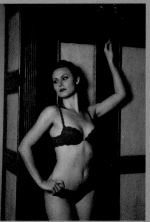

No.5

POSING WITH MIRRORS

Posing in mirrors can be a bit tricky because you must contend with lighting and your own reflection. Shoot from different angles to get the best position.

Avoiding your own reflection can be difficult if space is restricted. Here are two ways to deal with it. First, you can shoot wide-angle with a much shorter focal length as planned, then step more to the side and crop the image later on. Alternatively, you can use a rather long lens and shoot from outside the room. With such a small image angle it's pretty easy to get yourself out of the reflection. If everything else fails and you just can't find a spot where you won't show up in the shot, you may need to resort to retouching to make an otherwise great photo work.

PRO TIP

To avoid reflective flash in the mirror if you are using on-camera or off-camera flash in the bathroom, try bouncing the flash off the nearest wall. This will eliminate the harsh reflective flash in the mirror with the subject. If you own a tilt/shift lens, this also can be used to avoid your own reflection in mirrors by shifting it to the side. This technique is similar to shooting very wide and cropping, but you won't lose parts of the image.

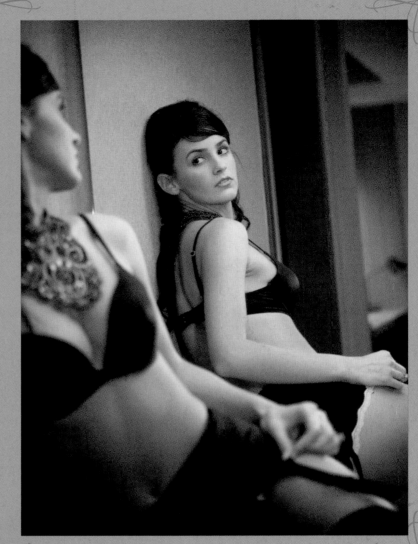

Examples of posing with mirrors.

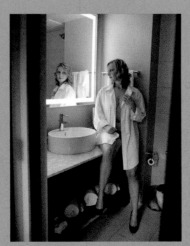

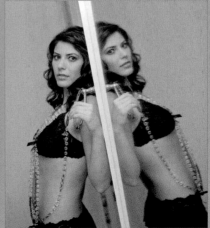

No. 6

WALL POSING

Wall posing can be a tricky but also fun and creative way to pose. Make sure never to have the client stand straight back against the wall, as this is not very flattering.

Ask her to lean with her backside against the wall and her torso leaning out. You may also have her lie on the floor and prop her legs on the wall. Having her sit and lean against the wall in different positions will make for lots of variety as well.

You can even have your model stand facing the wall with her hands on the wall and her face turned sideways—shoot from behind or in a very narrow angle along the wall.

Work with the wall's pattern. If it's completely blank you can get some structure by using a spotlight or a gridded strobe. If the wall has large patterns that might become distracting, you can position your model a few feet away from the wall and blur out the background. In addition, use a light source close to your subject to have a strong light fall-off and a darker background.

☛ PRO TIP

Always remember to look at your subject from different angles, such as shooting from along the wall to behind the subject or straight on. This will give you more variations.

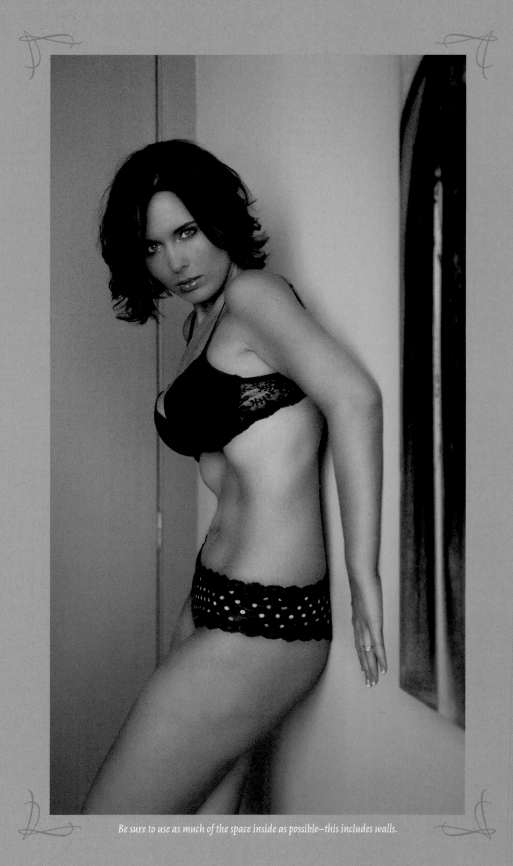

Be sure to use as much of the space inside as possible—this includes walls.

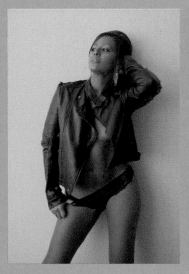
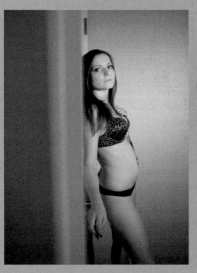
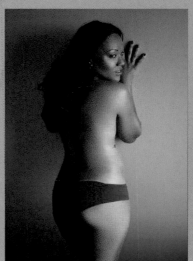
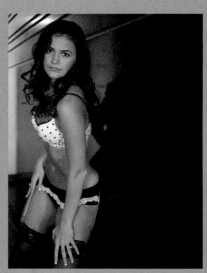

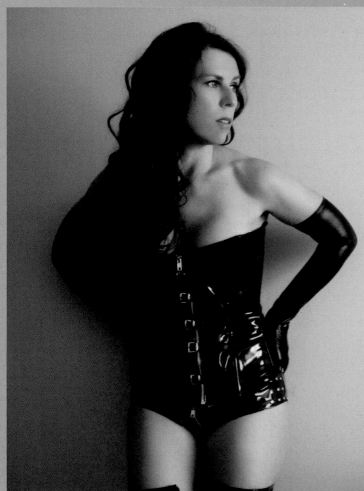

TOP, LEFT TO RIGHT: *Dynamic, varied wall poses make for exciting pictures. A smooth monotone background places emphasis on the contours of the model's body—use this to show off her best assets, whether a narrow waist, toned legs, or a smooth derrière.*

ABOVE: *Here the wide expanse of white space allows the image to "breathe," drawing the eye insistently toward the model. Note also how her shadow contrasts with the brightness of the wall on her other side, further drawing the viewer in.*

No.7

FLOOR POSING

For floor posing, unless you are shooting straight down on the subject, having some kind of backdrop will make the image flow better. Whether it is a wall or a bay window, try to keep the background simple, as you want your subject to be the main focus.

You can always blur the background by using a large aperture if it is distracting. Having a window with a great view can make for some dramatic shots.

Many floor poses can be similar to what is done on a bed. However, it is even easier to shoot from above if the model is on the floor. Also consider moving down low and shooting along the floor for an uncommon perspective. Aim at the subject's gorgeous eyes, or simply take a sexy shoe shot, showing her calves.

PRO TIP

Be careful how you have the client hold her head for floor posing—always look to see if her neck looks awkward so you can have her change position if it does.

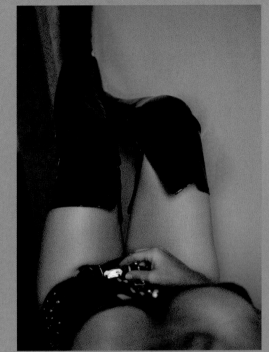

Getting in close and low gives an interesting shot which misses out the model's face, focusing on her midriff.

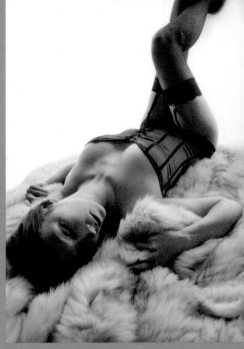

Using blankets, coats, or clothing for the subject to lie on while on the floor can make the image unique.

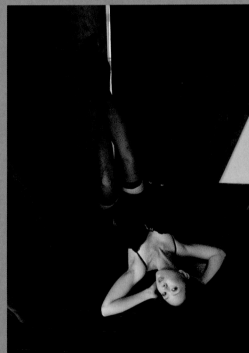

Laying half on the floor and half on furniture or on the wall works really well.

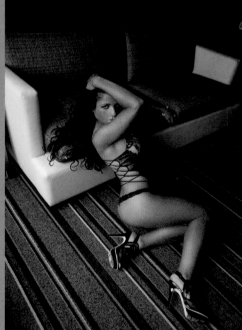

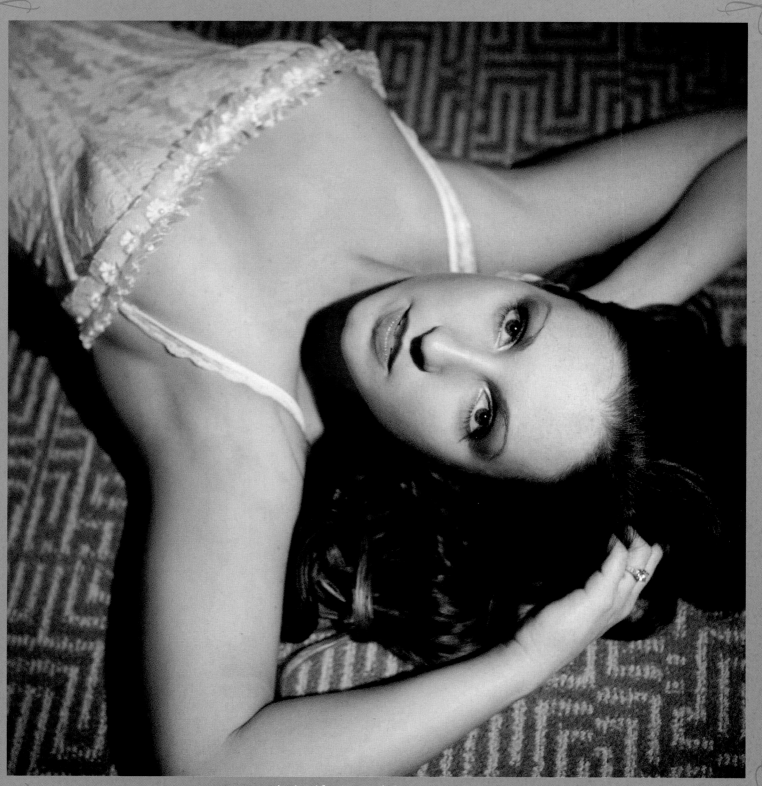

Carpet or hardwood flooring can make for an interesting background.

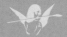

No.8

POSING
WITH PROPS

Props can make for great photos. I've learned never to assume that a prop a client brings will be cheesy. Some of my best images feature props I thought would be cheesy. The key is making the image tasteful and using the prop to your advantage.

Sports jerseys are a popular item for women to bring to their session. Sometimes this prop can be a challenge if it is large on the subject. In this case have the client drape the jersey over herself rather than wearing it. Necklaces can make for a great focal point to showcase other assets the client wants to highlight. The subject may also wish to hold a necklace to give her something to do with her hands. Hats are also a great prop to include, whether the client wears the hat or holds it for the image.

Very often just putting the hands up to a prop like a hair flower or some jewelry can emphasize the prop and make for an interesting pose.

There are many ways to use props in photos, and being creative will give your client a greater variety of shots to choose from when her session is done.

High-heels suggest glamour, power, and sensuality—zoom in on them to magnify this effect.

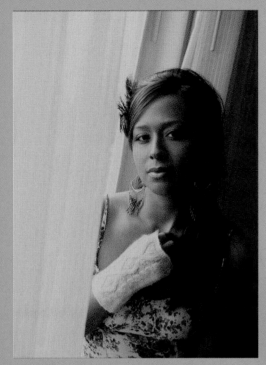

A harmonious atmosphere can be achieved by
using props with colors that chime well.

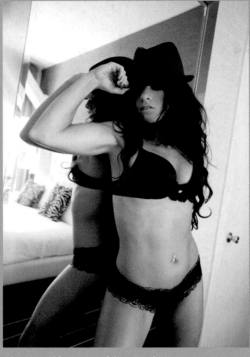

Hats may add variety and drama to the image
and make for a nice prop.

▼ **PRO TIP**

*Remember to try different
angles when using props—it
can dramatically change
the look.*

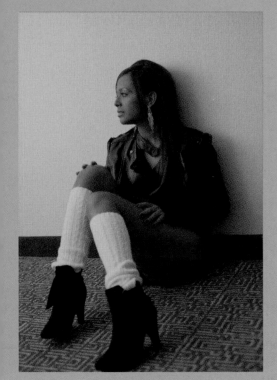

Knee-high socks, stockings with heels, or boots can
showcase the client's legs.

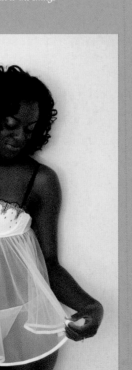

Select props that add a new dimension to the image.
This sheer nightie adds texture.

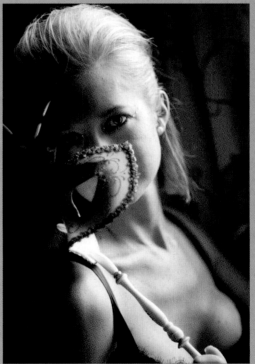

Partially covering the face adds mystery, as in this
image incorporating a Mardi Gras mask.

No. 9

POSING IN THE BATHROOM

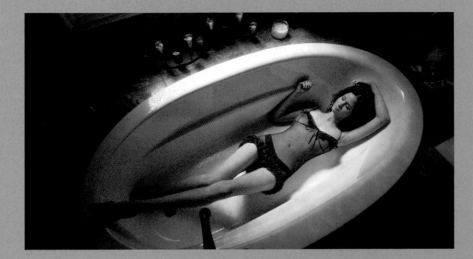

Bathrooms can be a great location beyond the bedroom. Use mirrors, tubs, and countertops to pose your subject. If there is a large tub, have the client lie in it with her heels on for a dramatic effect. If your client is open to having the tub filled with water and some bubbles, go for it, as this can make for a sexy shot. Mirrors can make for sensual photos by having the client primp, fixing her hair or putting on lipstick. If you have enough counter space, have the client sit on the counter and lean back in a relaxed position.

Leaning against the tub on the floor is another great way to use this room. Try different angles, and if your subject has a sense of humor you could even have her sit on the potty for a fun image—with lingerie on, of course.

PRO TIP

If you are working with a filled tub, use only battery-powered lights or make sure that all necessary measures are taken so that power cords and lamps can never be a hazard to anybody on the set. Also be aware of tiles that can get slippery when wet.

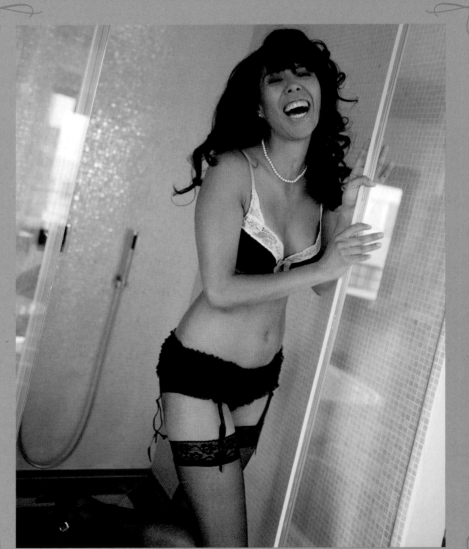

Posing in the shower and around the bathtub can make for interesting shots.

№.10

POSING OUTSIDE

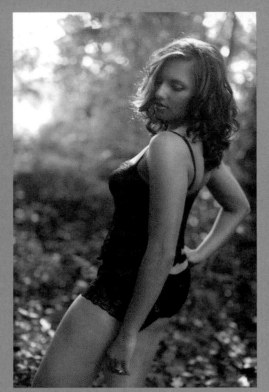

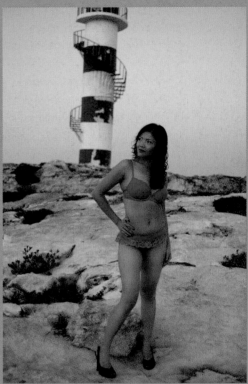

Nature boudoir can be fun and interesting. Shoot by a stream or by an old barn for a rustic look. Before you plan your shoot, make sure it fits with the style the client is looking for.

Choose your location and then figure out if you will need to bring props or furniture to add to the shoot. Outside has so many options for posing: in a nature environment you'll find trees, fences, barns, and rocks. And of course any waterfront can make a great setting—look for a stream, a lake, or the sea with a sand beach, pebbles, and beach chairs. In an urban surrounding, use buildings, doorways, alleys, or even the street. If you are shooting in a field you could bring a chair or a chaise lounge to use. Other props that can help with posing are umbrellas, raincoats, cars, bicycles, and motorbikes.

► PRO TIP

When shooting boudoir outdoors you will need to take extra caution to maintain your client's privacy and not arouse public attention. This concerns the times when you are taking photographs as well as when your model is changing. If you are in a remote area this can be easy, but in more populated areas it can become a challenge. Never get your model (or yourself) in trouble. If necessary, provide some privacy with a held-up blanket or one of the changing tents or tubes available on the market. In some cases you may also be able to use a nearby place's restroom to change.

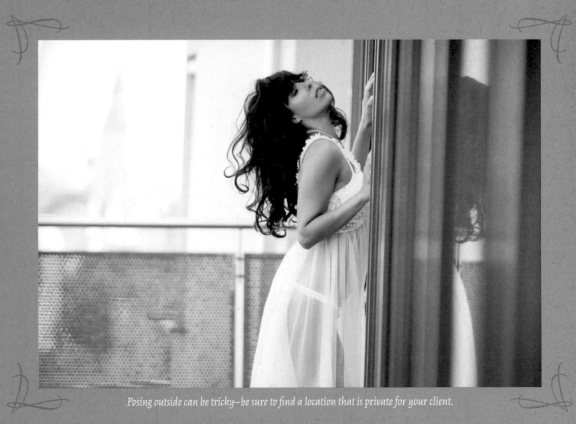

Posing outside can be tricky—be sure to find a location that is private for your client.

No. 11

POSING BY WINDOWS OR DOORWAYS

No matter what kind of space you are shooting in, windows and doorways are great for posing your subject. Have her stand in the doorway in different ways—even sitting can make for a great pose. Windows can be great for sitting in or for the client to look out of or lean against. Try as many poses and angles as you can to create variety.

With both windows and doorways, there is usually something beyond the frame that you can incorporate in your shot. Framing your scene this way is always a great way of composing. It can enhance your model's pose since her shape shows against the background. You can also have your client stand centered in a doorway or in front of a window, which frames her. Adding some backlight can make for a simple yet very dramatic setting.

When standing with her back to a doorway, ask your model to step away a little bit and then lean back with her shoulders. This will create a nicely arched back and a beautiful shape.

When your model is close to a window, always consider what can be seen from the outside. If the public can see, it can make your client very uncomfortable. Having her move away from the window a foot or two can often solve the problem.

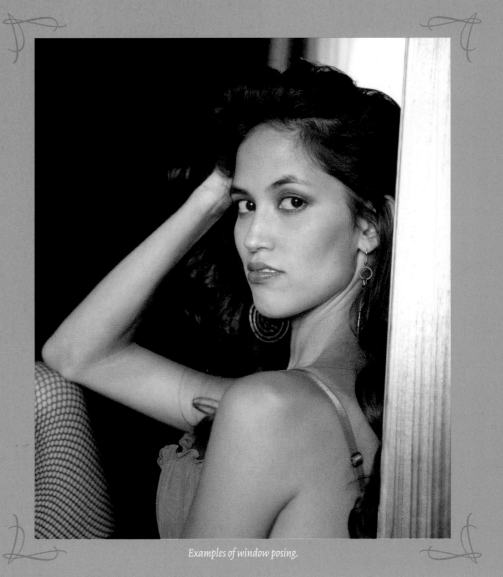

Examples of window posing.

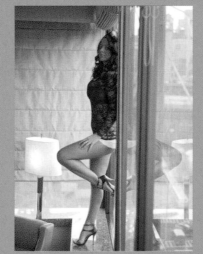

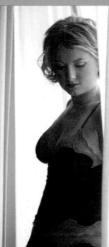

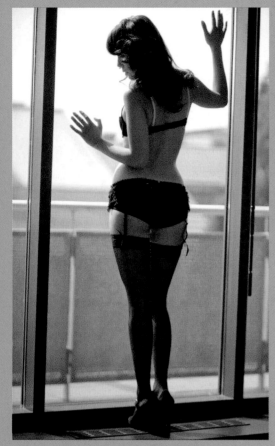

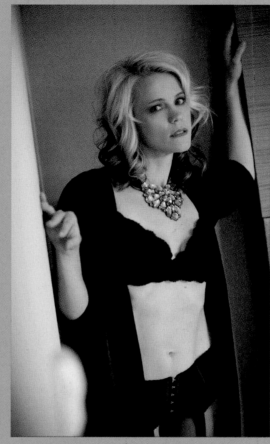

PRO TIP

Lights in the background seen through the doorway or window can drastically add to the mood of the shot. Often shifting your camera just a few degrees can catch some lights and draw them into the scene.

Examples of doorframe posing.

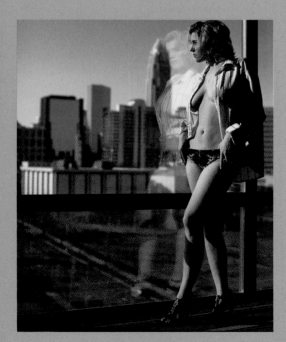

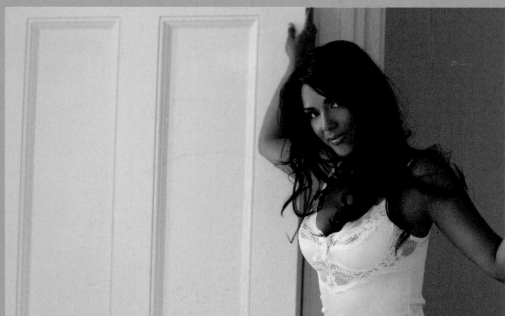

No.12

CORRECTIVE POSING

The right pose can correct for flaws; the wrong pose may be unflattering, even on the most slender person. Train yourself to always look at the whole picture in front of you. Analyze photos you or somebody else took in which something doesn't look ideal, and learn from it. Remember, a five-second correction can save you 15 minutes in retouching!

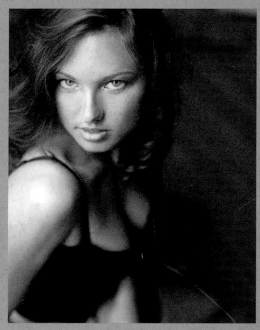

Shoot downward toward the subject to eliminate any concerns of a double chin.

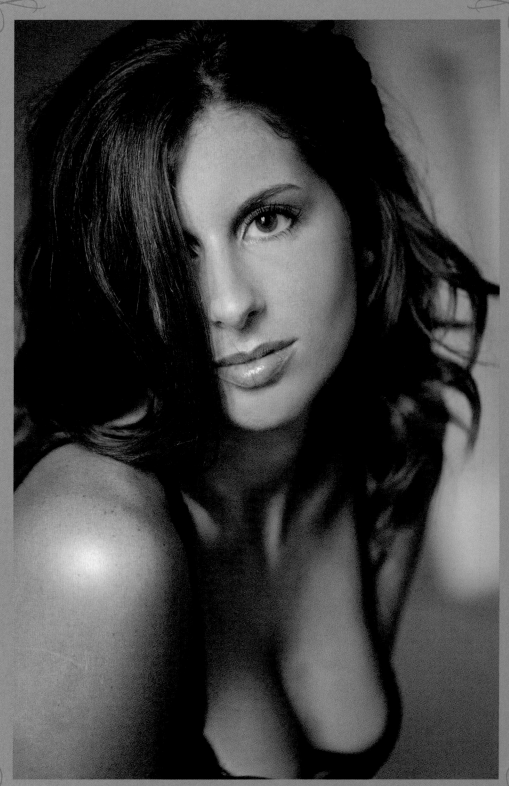

When shooting close-ups be sure to use a standard or telephoto lens. Wide-angle lenses force you too close, causing significant perspective distortions.

Slimming Angles

One of the simplest rules is that photographing a person directly from the front will make her look wide. So have your client turn in a bit, either her whole body, or just her upper body. The half-profile will appear much more flattering. Shooting upward from a lower standpoint is very likely to cause trouble if your model is anything other than very slim. Perspective will cause everything closer to the camera will look bigger, and in that case it will be thighs, belly, butt, and jaws—exactly what you don't want! Shooting from a slightly higher standpoint, on the other hand, will hide double chins and bellies and will make the eyes appear larger.

Slouching

Correct your model's posture if she slouches or hunches her shoulders. If her tummy is a bit larger, slouching will pronounce it even more. While standing or sitting, an upright posture makes a person appear thinner and will enhance the bust.

Holding the head or upper body up while lying down is not only stressful and uncomfortable for your subject, it can also make muscles and ligaments appear, showing how uncomfortable the pose is. You can ease such a pose with a supporting pillow.

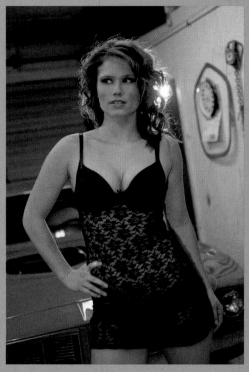

Have the subject bend elbows and hold her arms slightly away from the body to show curves and not make the client look wider than she is.

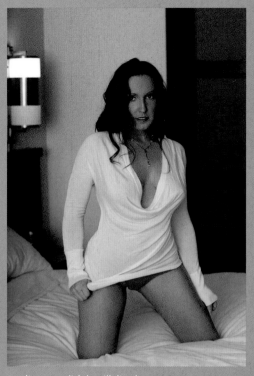

Bending arms slightly will slim them.

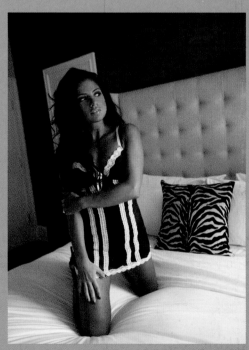

Have your subject turn slightly away from you for a slimming effect. This works for all body types.

Shoot from a distance, which will make the subject appear smaller.

No.13

DIFFERENT BODY SHAPES

It is imperative to adjust your posing to the type of body your client has. There are many different shapes and sizes of women, and they can all be a challenge. You would think a petite client would be easy or a tall client a breeze to photograph, but there are things to watch out for when photographing different body types. After all, all clients want to look beautiful, and it's our job as photographers to make sure they will get photos they look stunning and sexy in—photos they love and are proud of.

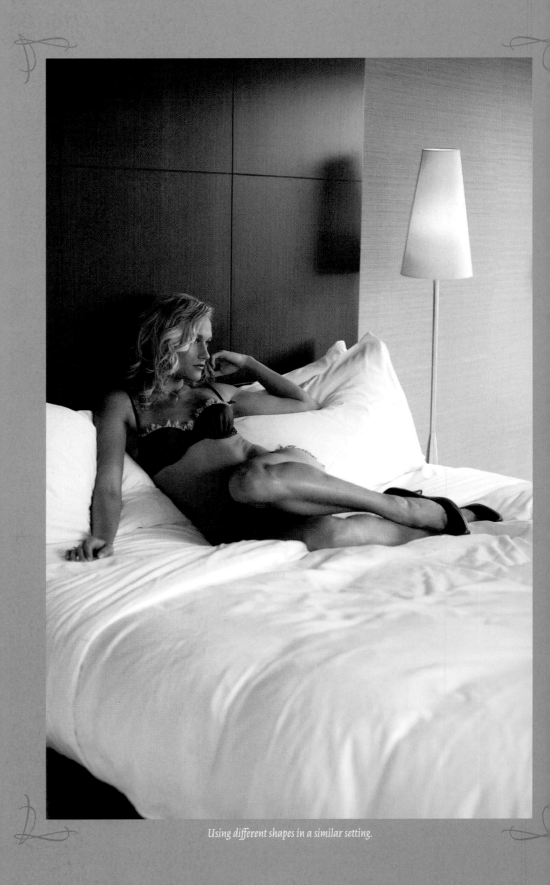

Using different shapes in a similar setting.

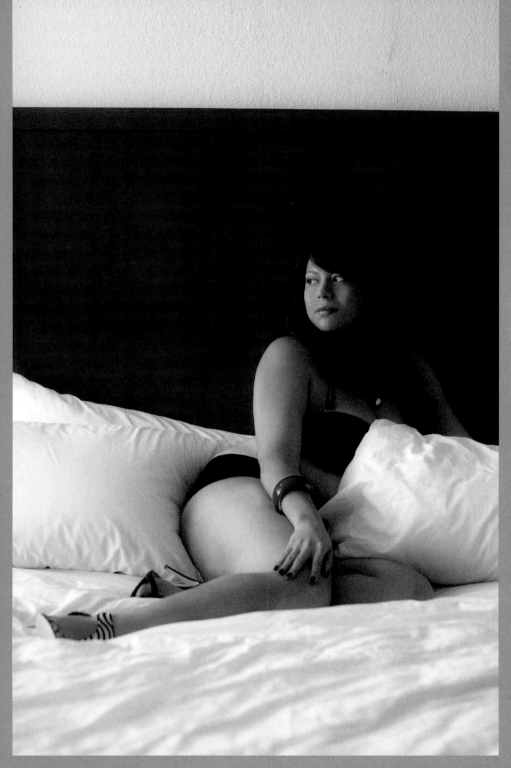

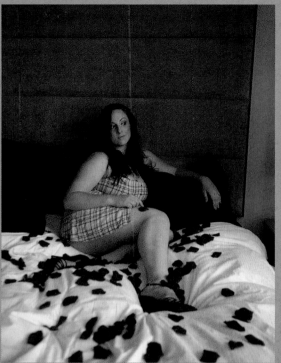

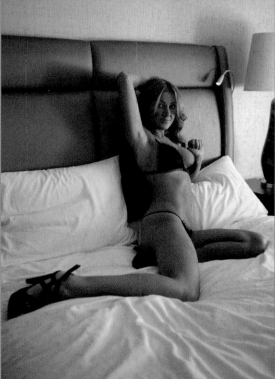

No.14

SMALL BUILD

A petite subject may appear to be smaller or even childlike with some poses, which is a disaster in boudoir. Be careful to avoid making her look smaller than she already is. A common mistake is shooting straight down, which creates a shrinking effect. This might work with a really tall client, but it never looks nice on a petite subject.

It takes some practice to find the right position for a petite model, since you also want to avoid shooting up too much. A good way to approach it is to emphasize her legs and avoid making her look bigger than she is. Apply the principles discussed in the section about corrective posing (p. 74), and don't have her sit in poses where the thighs and calves are compressed. Of course, higher heels will always help. A good shooting technique for smaller-built subjects is a slightly lower viewpoint, but holding the camera straight and not tilting it upwards. If you get too much floor in the shot, crop it later. This viewpoint will visually extend the legs and it will make the model seem tall in relation to the room.

⚑ PRO TIP

Using a fixed lens such as a 50mm for petite and tall clients can help keep the subject in perspective. Wide lenses can distort your subject from different angles.

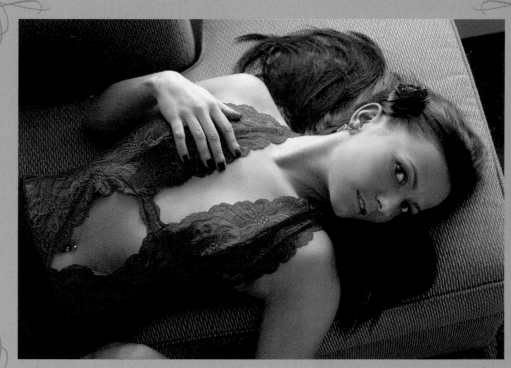

Shooting down at a smaller subject while she is lying down is okay, but do not shoot down the length of the subject as it can make her appear smaller or childlike.

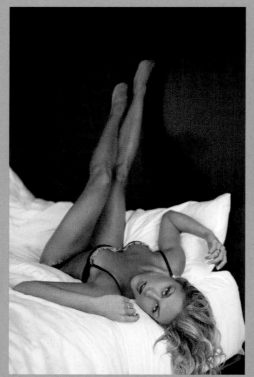

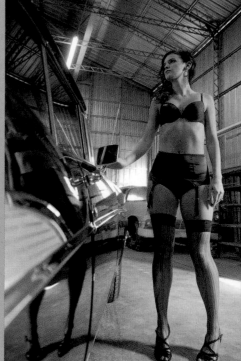

Shooting with a wide lens can make subjects look taller.

No. 15

TALL BUILD

Photographing taller subjects from different angles can make them look even taller, especially if your standpoint is low and you are using wide-angle lenses. This can work to a certain extent, but there are limits. Very tall subjects may preferably be posed sitting, either on chairs or on the bed or floor, where they can pull their legs up a bit to showcase their length and slenderness. Wrapping the arms around the legs in this pose also works well for taller models, since the upper body still keeps some distance from the legs.

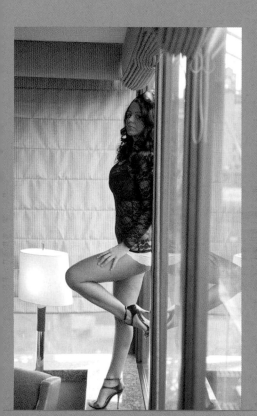

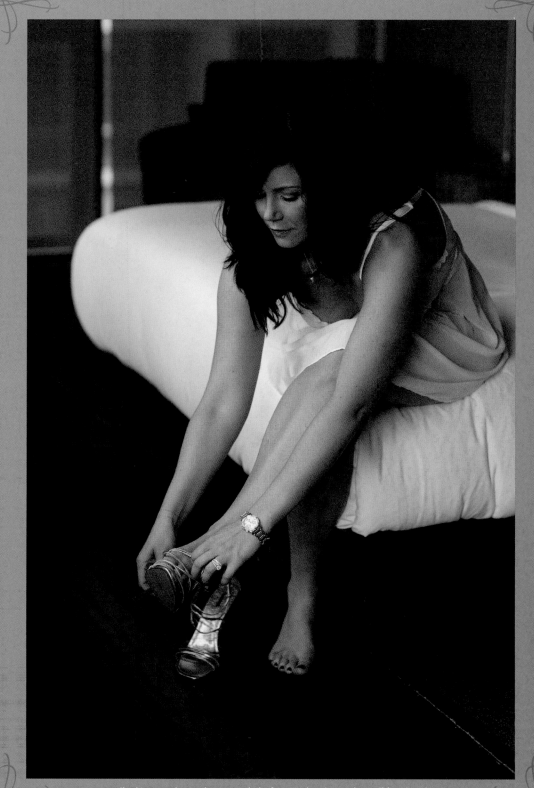

Tall subjects can be posed sitting with the focus on their legs to show off their length.

No.17

PLUS SIZE

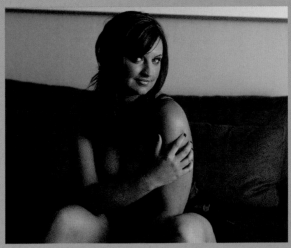

Having the subject lean in and cross one arm will slim her.

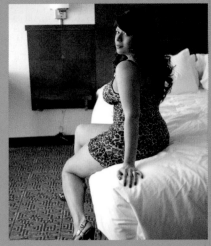

Side angles can show off dramatic curves beautifully.

Some clients are very comfortable with being plus size; others are rather self-conscious about it. Usually it's not hard to find out how a model feels about herself in the conversation you have with her while she is getting ready or having her hair and makeup done. When photographing plus-size subjects, pose them in creative ways to showcase their best assets.

Any poses that slightly twist the body and don't present it straight and frontal to the camera will result in a more flattering image with curves and softness. Avoid taking it too far, since creases will show and the result will become less attractive. Again, it's rewarding to choose the right things for the model to wear: never anything tight, but also nothing that is too loose and makes your client appear even bigger. Look for pieces that are cut in such a way that the waist is pronounced and the focus is taken away from hips and belly.

Poses in which the model lies on her belly and looks up to the camera, or sits turned toward the chair, work well. Posing lying on her side with a knee up will create a slimming line. Having the client lie on her back with her arms up will also create a slimming effect. You may use props and pillows for slimming poses, like using the bedsheet pulled halfway up while in a sitting position. Any fabric to drape over problematic parts will round off a beautiful and sensual photo of any plus-size woman.

Bigger arms can be dealt with by a clever crop and, when lying down, the same applies for the legs—never let them appear bigger by compressing them. Stretching arms will prevent the forearms from looking bigger, such as putting hands on hips or stretching them over the head.

With plus-sized bodies it is not uncommon that the skin does not look as smooth on certain parts like arms and legs when light from a shallow angle and shadows emphasize unevenness. Using flat lighting with a large light source and avoiding sidelight will correct this.

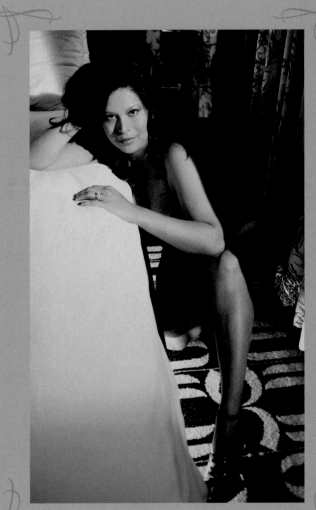

Having the subject pose and using shadows can make her appear slimmer.

No.18

LARGE BUST

For women with a larger bust the right support is crucial, and you should always make sure that bras and bustiers are not too tight. When your subject is lying on her side or back, adjust the pose so that there is not too much asymmetry. If you pose her on her belly, make sure that there is sufficient support or that the bust is in contact with whatever she is lying on to maintain a flattering shape.

▼ PRO TIP

When you have a larger-busted subject in a lying position, her bust may look uneven. To correct this, have her lie slightly turned until she looks more even.

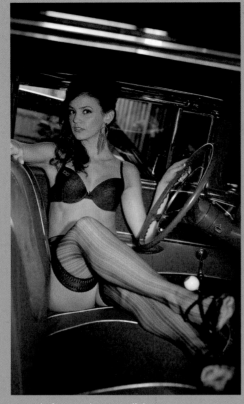

Correctly fitting underwear will showcase your client's assets to her full potential.

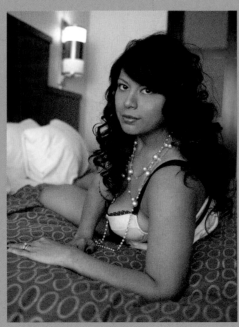

Having the subject lie to the side and shooting toward the length of her body will elongate her— make sure that her bust area appears even.

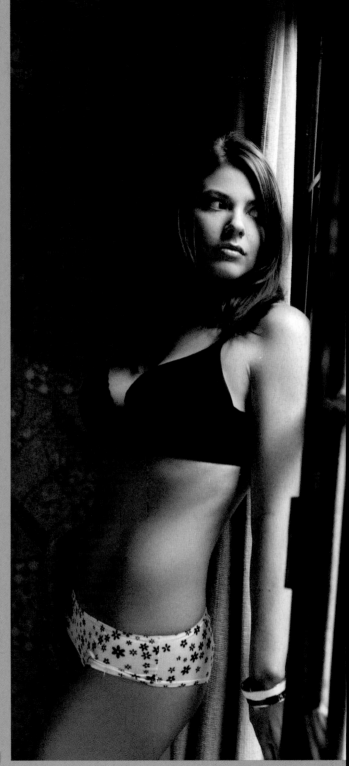

Experimenting with light can sculpt the subject's body and give you beautiful results.

The Shoot

IT's THE DAY OF THE SHOOT, and you might ask yourself where to start. But after a while you will develop a clear system of working that will help you move through a session efficiently. Try to learn about your model's wishes and expectations as much as possible and come up with a plan of how to realize them. Whether you shoot in a studio or on location, be prepared for the client by having everything set up beforehand. If you have to set up lights, do so before the client arrives to prevent her from having to wait. I like to have music playing to help set the mood and will ask the client to bring her iPod or provide my own—I have this ready so we can just pop it in and have it play. If you are providing wardrobe, have everything laid out and ready to accessorize. If you have a stylist for the shoot, have him or her come early to set up as well. You never want to keep your client waiting—this only adds to her nervousness.

Lighting

I choose lighting based on the mood I want to achieve, as well as on the conditions I expect to find at the location. If you are shooting in a studio, you are totally in control. On location, however, you might find perfect window light…or a small hotel room with barely any light coming in.

IN THOSE SITUATIONS you can either set up lights in a conventional way—with a softbox or an umbrella as a main light and fill light if necessary—or you can emulate daylight, or photograph a setting with room lights and an evening or night mood. I get more out of each lighting setup by moving around my model and shooting different angles while the light goes from flat to three-dimensional to dramatic to silhouette. Working this way will yield a great variety of photos and will also teach you a lot about light directions.

Remember, at a boudoir shoot you are not dealing with professional models and staff, so be extra careful how you set up light stands and run cables.

Light is important for separating and defining dimension. Always watch for problems where your subject might not separate sufficiently from the background. Dark hair and a dark background can be separated by throwing a rim or hair light on your model; set it behind and above her, positioned just out of the frame.

Skin tone plays another big role in how you set your lights. One rule of thumb is that light skin is defined by shadows, and dark skin is defined by highlights. The same is true for clothes and most other surfaces. For a light-skinned face set your light so that shadows are cast and see how nicely they carve out dimensionality. For a dark-skinned face set an additional side light that hits the edge of the face and beautifully shows edges and texture.

Whenever you set your lights, pay attention to the eyes. Light in the eyes—and in many cases a catchlight—is a must whenever the eyes look at the camera. Don't let dark shadows in the sockets ("raccoon eyes") destroy the impact eyes can give an image.

The following setups are all very easy to accomplish, yet yield beautiful results.

The first setup results in a very clean and "studio-like" look: a softbox or an umbrella not too far off camera axis with enough fill

BELOW LEFT AND BELOW: *Window light can be just as dramatic as studio and video light—it just depends on how you use it.*

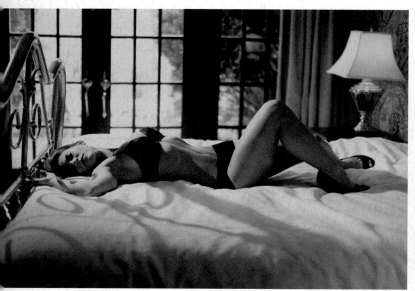 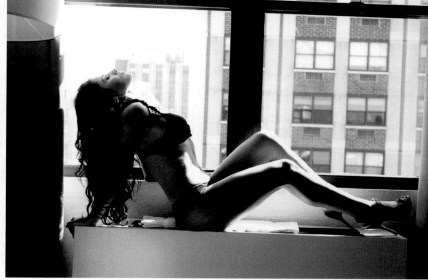

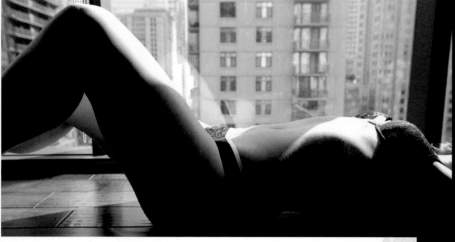

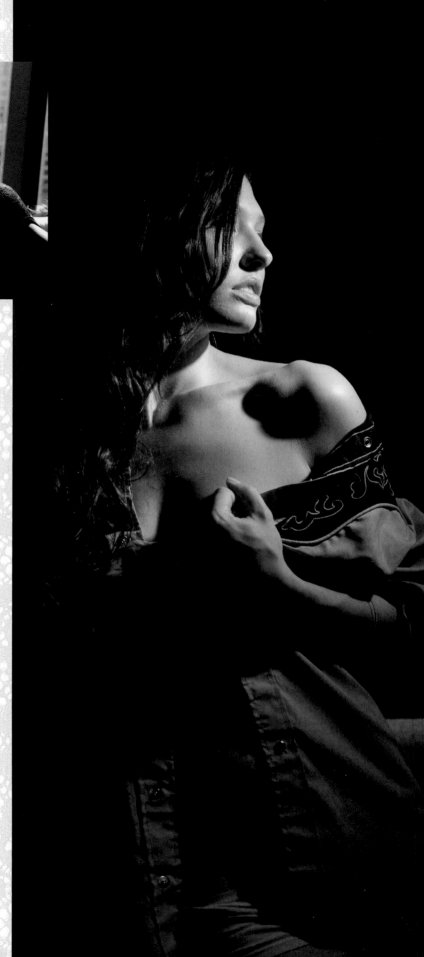

ABOVE AND RIGHT: *Shadowing just on the body can be very sexy.*

from across to get pronounced, yet not too deep, shadows. Bringing in a large softbox as close as possible will generate a soft wraparound light that flatters your model and evens out most skin imperfections.

A similar setup but with a beauty dish or a small reflector farther away as a main light will give you a crisp, fashion-like look that is similar to direct sunlight, especially if you fill the shadows only very slightly. Be aware, however, that this type of light is way less forgiving and works best with women who have good skin and even features. Shadows will be much more pronounced, and you will need to be more precise with your posing to avoid unpleasant results.

Even though I have a nice array of different lights, my core set of lights I take to every shoot is pretty basic:

* *Alien Bee B800*
* *60" umbrella with removable back*
* *A medium-sized light stand*
* *A set of PocketWizard radio triggers*
* *A Lowel Pro-Light hot light with barndoors, modified with a dimmer (+ a spare light bulb)*
* *An external flash unit*
* *A couple of Sunpak Readylites (these are tiny battery-powered video lights for around $30)*

This is what I always bring; depending on the shoot I will extend this with other lighting tools.

Learn to "see the light." Lighting is so important for creating beautiful photos of the human body, and you should acquire a sense for the direction and quality of light in every location you shoot in. This awareness of light not only helps you make the best of any shooting situation, but also helps avoid common mistakes. I am constantly surprised by how many photographers do not notice when somebody is standing in their light, blocking it, or even casting a shadow onto the scene.

Directional light, such as window light, is one of the most beautiful lights, and you should make use of it whenever you encounter it. You can get pretty dramatic with little fill or even shooting toward the window, blowing the window light out while creating a silhouette type of image (see far left, left, and above). Unfortunately, there are days or locations where window light is subpar. I had to deal with this at a shoot where the hotel room's ceiling was low and the weather outside made for dim and murky light. Still, there is a way to get something close to window light with a studio strobe. If you bounce it off a white wall or neutral-colored curtains, you can get pretty close to the magic of window light. Sometimes I position the strobe even behind the curtains and shoot it away from the room. The light will be extremely even this way.

If you prefer the available light in a room, bouncing a flash off a room corner is a great way to raise the light level. You can gel the light to bring it close to the room's ambient light. I often use lamps on tables and desks—in room corners and around mirrors as accents in the background, or even as contributing lights, for a setup with lots of mood. Shooting with a high ISO may be mandatory in such cases.

Outdoors

Boudoir photography does not necessarily need to be indoor photography. Even though it might not always be easy to take these kinds of photos in outside locations, the outdoors can be a great alternative to inside shoots. There are many cases when you can get amazing pictures without any additional lighting tools, especially when you set up your scene according to the conditions. Some say that there is no bad light, and to a certain extent that's true; you can work with what is there or modify it to your needs. For instance, in a situation where all I have is harsh noon sunlight, I may photograph the model from a bit farther away and try to let the

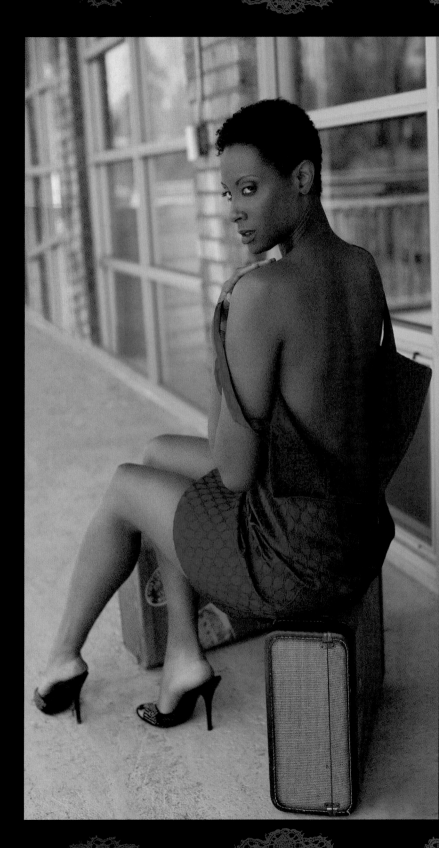

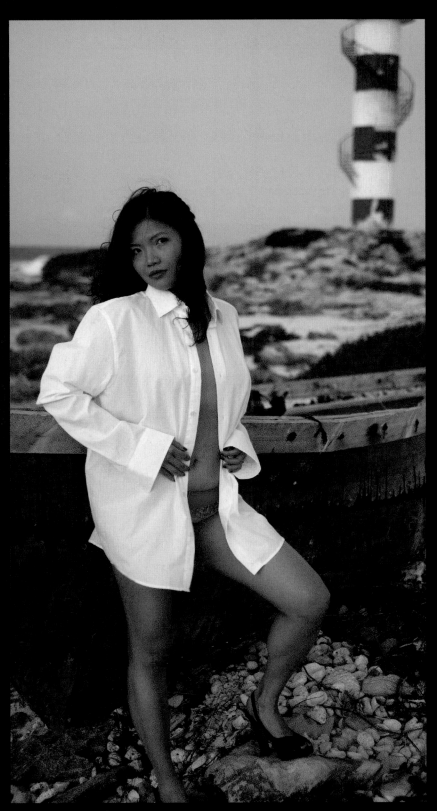

strong shadows model her shape. Or I have her turn her face away from the direct light and expose for it, while blowing out other parts and maybe even incorporating some lens flare.

On the other hand you can set up a diffuser to block the direct light without creating shadows that are too deep, and then create your own light with a reflector. Much fashion photography is shot exactly that way, because it gives you enough control over subject and background while using simple tools.

Another thing I do with harsh sunlight is to use it as backlight, and then add flash or light from a silver or gold reflector as the main light. Be aware that using reflectors, especially with direct sunlight, can blind your model, or at least make her squint. Avoid having her look directly at the reflector. If you use flash in those cases you must obey your camera's highest shutter speed for use with flash (the maximum sync speed). Use the lowest ISO setting and, if necessary, stop down the aperture or use neutral density (ND) filters (also called gray filters).

Things are less complicated if you work in open shade or at times when the sun is low and the light is soft. The color casts in those situations can be desirable and add to the mood of your setting. If you want more neutral skin tones while preserving the cast in the surrounding scene, either put some flash on your model or in open shade get direct sunlight onto the model by using a reflector.

Overcast days are the other extreme. The light can be very soft and flattering, but it can also tend to be too flat. I add a bit of flash to provide the necessary bit of sparkle or have a black panel or a dark doorway to one side to bring back some three-dimensionality. If the cloud layer is changing constantly, waiting for the moment when the sun is just about to burst through the clouds also gives you a light that is smooth, yet has more punch and sparkle to it.

A real-life photo session might take the wind out of your creative sails and let you fall back to your best known standards. Therefore it makes sense to work on enhancing your skills and raising your standards, and working with outdoor light is part of this. Also, toward the end of a shoot, when your model is more relaxed and you have all the "must haves" in the box, it may be time to try something new and experiment—this is a good time to take it outdoors. Thinking outside of the box can easily result in the one shot that will make your session shine.

OPPOSITE AND LEFT: *Always pay attention to the light when shooting outdoors, and avoid having your model look directly at the reflector, at the light, or into the sun.*

Shooting handheld

Current equipment allows us to shoot handheld most of the time, and doing so will definitely yield more variety from each pose. Whenever I have set up a pose I move around my subject to explore different angles and to benefit from how the lighting changes in the different positions.

IMAGINE DOING ALL THIS with your camera on a tripod! It's hard enough moving it around, but once you think of going up high or down low, you will spend more time adjusting your tripod than shooting. One of my signature shots is to give a slightly more voyeuristic view by incorporating a door frame or other object in the foreground, and these are situations where handholding the camera is imperative. This also holds true for the instances when I need to get onto the bed to be close to the model.

However, handholding the camera also bears the risk of introducing camera shake, especially since we often end up with rather low light intensities on location. Unless you are solely using flash as your light source, you should consider this whenever you set your camera. Long shutter speeds are likely to impose camera shake. So how low is "low?" There is an old rule that says you should always set your shutter speed no slower than the reciprocal speed of your focal length. Example: if you have an 85mm lens, set your shutter speed no slower than 1/80 or 1/100 sec., since there is no 1/85 sec. shutter speed.

But beware! This is only a rule of thumb. As a seasoned photographer you might be able to handhold slower speeds. On the other hand, it does not take any of the subject's movements into consideration. If you work with a 24mm lens and have your camera set to 1/30 sec., you might not get any camera shake, but your subject might move and impose motion blur.

The rise of digital cameras has further decreased the validity of this guideline. Smaller sensors magnify the effect of camera shake as does the extreme high resolution current digital cameras provide. The best bet is to go for about double the shutter speed the rule implies. So shoot your 50mm lens with at least 1/100 sec. The low noise that today's DSLRs show even in very high ISO settings helps with this. Lastly, it also depends on the final size your images will be printed. A 5×7-inch print will not show slight blur. If you give full-resolution files to your clients, that's another story.

If you prefer to set your camera to Aperture Priority (A) or Program mode (P), always keep an eye on the resulting shutter speeds—they might be too slow for sharp pictures.

BELOW AND OPPOSITE:
These images were shot handheld with natural light.

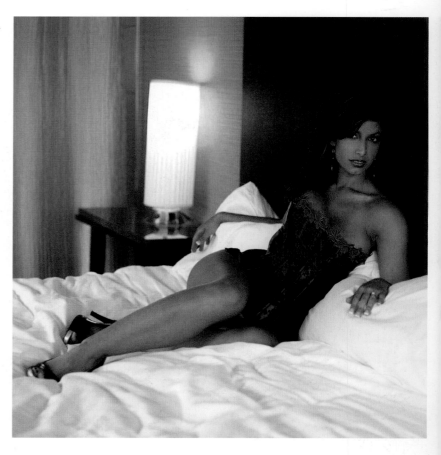

A lens with image stabilization (IS, also called vibration reduction, or VR) can help tremendously with reducing camera shake. Unfortunately, many prime lenses and some of the most used shorter zooms do not have it. If you have a camera with integrated, sensor-based image stabilization, you don't have to worry here.

Using flash as the main light will reduce or completely eliminate this problem due to the motion-stopping short flash duration. Even when you drag the shutter, your subject is mainly lit by flash, and you can get acceptable results since the background may already be out of focus and thus soft. Additional motion blur won't show up much.

There are situations in which a tripod is nice to have. A study of motion, or different poses, from a fixed spot can be done very conveniently with the camera on a tripod. A cable release for the shutter adds to the comfort of this setup. If you are shooting for an assignment rather than for a private client, a fixed position might be required. Tripods are also useful in situations where there is either not enough room for the photographer or where it's too dangerous for you to stand, such as an image of your model on a balcony, shot from outside the balcony.

PRO TIP

Too much equipment can become intimidating to a client when she is nervous already. A tripod can add to this. So if you are photographing boudoir sessions professionally with a large variety of clients, you might want to keep the set looking comfortable.

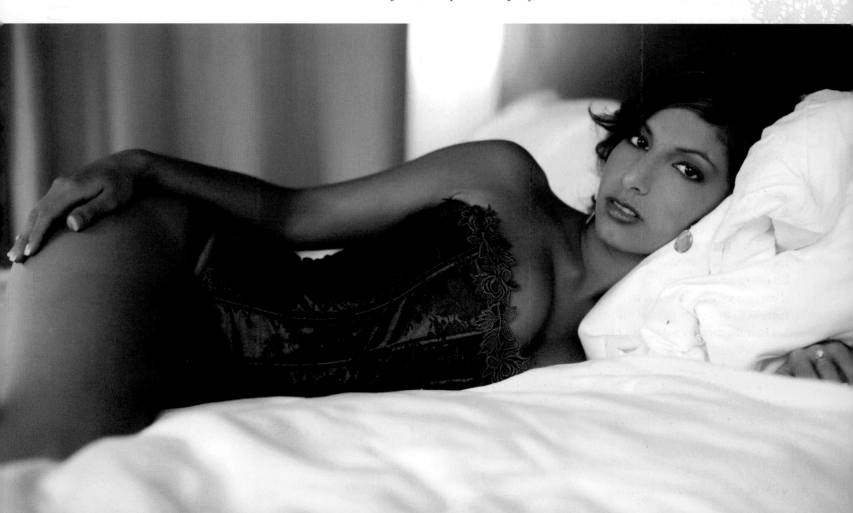

Creating your own style

Often photographers admire a particular style of photography and wish to attempt this style on their own. I encourage you to find a way to create your own style rather than simply mimicking the work of other artists.

CONSIDER THE THINGS THAT INSPIRE your work and, using this inspiration, brand yourself. This will set you apart from other artists, and your passion for your work will inevitably draw like-minded clients. Whether you find inspiration in the outdoors, high fashion, Gothic style, makeup, flowers, or vintage jewelry, use these elements to make your work unique. Ultimately the goal is to showcase the kind of work you would like clients to book you for.

PRO TIP

I have said this before but I will say it again— seek inspiration in everything you can, not just by looking at other boudoir photographers. All kinds of publications have great inspiration to help you get started.

BELOW: *Coming up with unique locations or poses will set you apart from other boudoir photographers.*

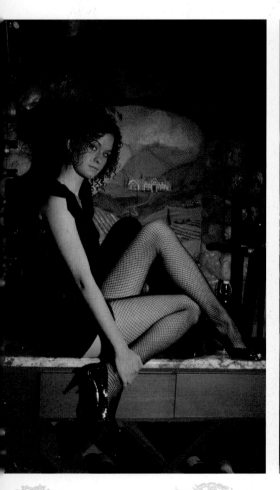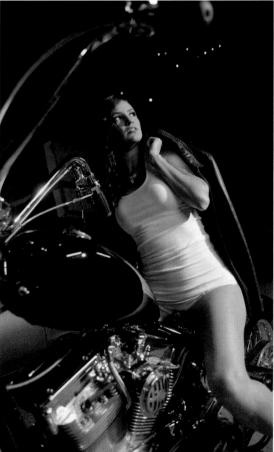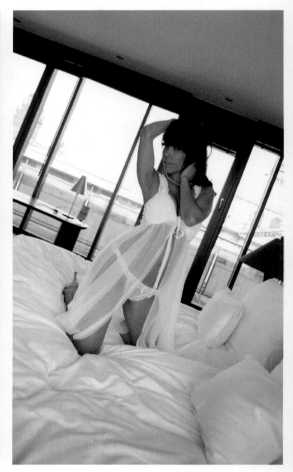

Interaction with the client

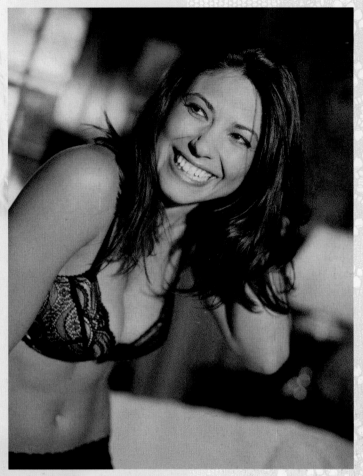

Depending on your client's personality and the look she is trying to achieve, you may want to adjust your photographic style to create a look that showcases her as an individual. Before the session, talk with your client to find out how she wants to portray herself. She may want to incorporate a theme such as a hint of vintage, or she may want to have a modern shoot.

WHILE IT IS IMPORTANT to use your inspiration to specialize in a style that is truly unique to you as an artist, be careful that your work does not become expected or mundane. One way to avoid this is to interact with your client during the photo session, drawing inspiration from her unique style. Get to know your client's personality and ask questions that help you understand how you can truly bring her style out in the session. Is she playful? Modest? Did she bring lots of jewelry or designer shoes to the shoot? These elements should encourage you to try new things, new perspectives, and new angles when working with new subjects.

PRO TIP

Make each model your muse to help bring out your best signature work while showcasing her unique style as well as yours.

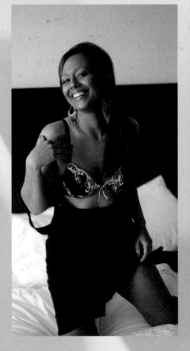
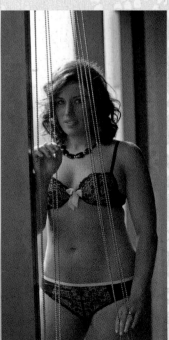

ABOVE AND RIGHT: *Making the client feel at ease will make for better shots.*

FAR RIGHT: *Use a longer lens to give the client space.*

Post-Production

COMPUTER POST-PRODUCTION plays a central role in boudoir photography. When photographing boudoir shots you will have more areas to retouch simply because you have more skin showing in the images. Retouching should always be done with "less is more" in mind so the client's skin does not look overworked—the last thing you want is for the client to look like plastic.

Processing workflow

At what stage you show the images to your client depends largely on your way of presenting and selling. You may upload your images to an online gallery and direct your client there or have her come to your place to view them as prints or on a projector or TV set.

YOU MAY LET HER SELECT before you have done any retouching or after you have applied minor retouching—if the image size she sees is not too big, this works pretty well. However, keep in mind that a completely unretouched image might make your client not want the image at all.

Here is the quick rundown for a typical processing workflow:

* Download cards
* Back up
* Select images
* Correct color, exposure, crop
* Modify tonality, set to black & white
* Retouch
* Design album or other products
* Archive

It should be mentioned first and last: back up, back up, back up! Eliminate the slightest chance that you could lose precious work. Once you come home from the shoot and download your cards, copy them to a second hard drive or burn a DVD, and make sure to set your computer up in a way that it automatically creates backups on a frequent basis.

When everything is downloaded and backed up, it's time for image selection. Keep the approximate number of images you will offer in mind. Since the retouching effort is typically pretty high with boudoir photography, you may be doing full retouching to only the images that the client eventually chooses.

Those images that you do show the client should get exposure and color correction as well as conversion to black and white or other tonalities where desired. Many photographers now choose software that accomplishes these tasks with minimal effort, the most popular being Adobe Lightroom, Apple Aperture, and Phase One Capture One. They all work on JPEG files as well as on raw files, although shooting and working in raw provides more flexibility without reducing the image quality when larger tweaks are necessary. All these software solutions provide some way of setting up presets to effortlessly perform repeating tasks. The first two products also allow you to catalog your work.

Most current computers are very well up to the task of image processing. Plenty of RAM and large, fast hard drives are only a minor additional cost, and can improve working speed dramatically.

Another important question is what file format to use for the end product—the images that you give to your clients on a CD or DVD, and what you will eventually archive. TIFF is a format that creates huge files and will not have any noticeable quality benefits. Some publishing houses insist on using TIFF images, but otherwise there is no need for this file format. If you want layers and more saved in Photoshop, then you can use its own PSD format for your own archive, but always consider how likely it is that you will want to reopen such files with all their layers once they are finished.

So generally, JPEG is the best bet for the images you provide to the client. This format does perform lossy compression, although if you have it set to higher quality there will be no visible impact unless you resave the image several times. Eighty percent, or quality setting 10 in Photoshop's JPEG setting, is a very good compromise between file size and quality. Photoshop offers an additional setting for saving JPEGs, Baseline Optimized, and this will reduce the file size even more.

PRO TIP

The most neglected but most important part of a computer for image processing is a very good, large monitor that is fully calibrated. This is where you set how your images will look, and even the results of the best photography gear can be spoiled when you have no clue how your colors and tonality really look. Skin is very prevalent in boudoir photography, and you need to be in control! Spend as much money on your monitor as you can, and then some. Compare what your screen shows with the prints you get back from a reputable lab. The most prevalent problem here is too bright monitors that make you feel the images you see are bright enough when in reality they aren't. Prints that are too dark are the result.

Selecting images in Photo Mechanic.

PRO TIP

Raw or JPEG? This debate will probably rage for years. However, current workflow software and low memory and CompactFlash card prices have diminished any convenience benefits of shooting JPEG. The potential that you have at hand whenever you need to make bigger corrections nowadays almost makes raw a no-brainer.

Selecting images in Adobe Lightroom's Grid view.

When it comes to retouching, all the workflow packages fall short and Photoshop still is the number one tool. Many great plug-ins (see page 112) and actions (see page 118) can dramatically help you with retouching. The most time-consuming task is cleaning up skin, reshaping and enhancing some parts, while hiding others. A graphic tablet can be very helpful for these tasks, since it lets you work very precisely and at the same time is much more sensitive than a mouse can ever be.

If you plan to offer albums you might want to use software that helps with their design. Photoshop is capable, but only when used with plug-ins does it become fairly effective. Though there are many programs on the market that specialize in album design, Apple's Aperture is the only workflow software capable of designing books. Professional desktop publishing software can also be a powerful tool for designing albums.

On the other hand, the books you offer may also be simple peel-and-stick albums that showcase twenty to thirty 5×7-inch prints. In that case there is no need to spend money on special software.

Skin tones

There is nothing human vision reacts more sensitively to than skin. And there are not many other types of photography that show more skin than boudoir photography. So be extremely particular about skin tones!

Get confident in your judgement of skin tones; if in doubt seek an opinion from someone else. Also, some people can discern color less well than others; men are more often affected by this than women. With training, feedback, and the use of tools like color numbers in software, this can usually be overcome, but it is something to be aware of.

The most obvious problem with skin tones occurs when they are too reddish, or, in technical terms, the amount of magenta in the color mix is too high. The less controlled your lighting environment is at the shoot, the higher the risk is of getting unpleasant skin tones. A typical scenario is when you are dragging the shutter (you are using long exposure times) to get much of the room lights, and then add flash. High ISO settings can have a similar effect. This can result in mixed light on the skin and an unpleasant magenta cast. The easiest way to correct this is to shift your white balance's Tint slider toward green. Working with raw files will give you much more leverage here. If this results in an unwanted color cast in the rest of the image, you might have to resort to local corrections, which most software products offer, be it masking or brushes.

Another thing that can affect skin tone is overexposure. Film was much more forgiving than digital is now; digital often shows hue shifts in overexposed segments. Again, skin tone is the most sensitive area. Different software reacts differently, but most of the time a shift to orange or magenta can be seen in overexposed skin. Try to avoid overexposing, especially when working in warmer light. If your camera can show a RGB histogram, make sure the R (red) channel is not severely overexposed. Raw processing software provides a control called "Recovery" (Adobe Lightroom, Adobe Camera Raw, Apple Aperture), "Highlight" (Canon DPP, Phase One Capture One) or "Highlight Protection" (Nikon Capture NX2), which can save some of the overexposed highlights. In tougher cases backing off the exposure slider and compensating with fill light can help—a technique that works exceptionally well in Lightroom. If all else fails, a conversion to black and white can save an otherwise great image.

A white balance card can make it easy to achieve correct colors and pleasant skin tones. Take a picture of the card, then click the white balance picker in your raw converter. You can always use this as a starting point and modify from there. Re-shoot the card when the lighting changes. Do not confuse white balance cards with the old gray cards that were used to expose correctly. These are not perfectly neutral. The WhiBal card is of highest quality and is extremely neutral and durable. There are also white balance tools that feature tinted fields of gray that will warm up or cool down an image when clicked on. X-rite's ColorChecker Passport and ColorRight are prominent examples.

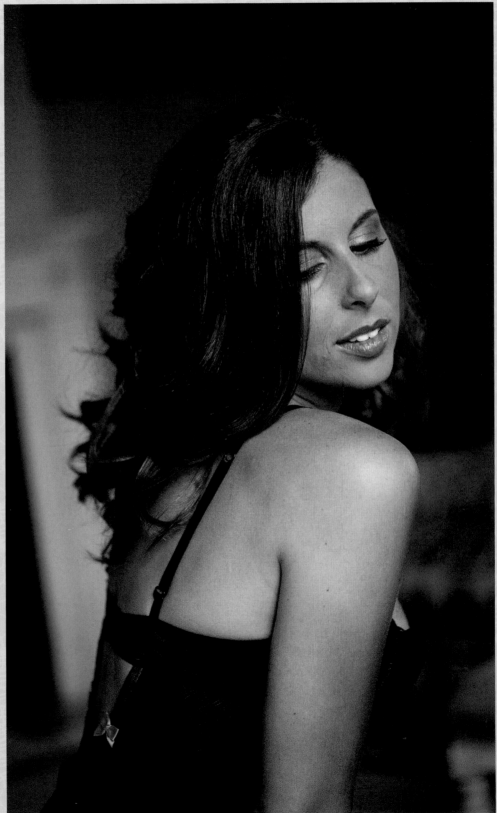

BELOW AND RIGHT: *Very cool and bluish window light from a clear blue sky rendered the skin cool and pale. Sometimes the camera's auto white balance can correct successfully, sometimes not. Different camera makes and brands vary widely in their auto white balance capabilities. In this case, the color temperature was raised in the raw converter's white balance controls.*

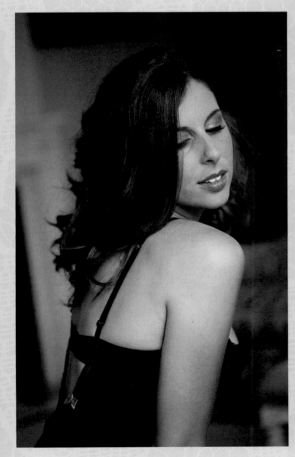

It is hard to judge skin tones if they are only a small portion of a photo; in such cases, zoom in while you are color balancing for pleasant skin tones. Depending on your style, you might love highly saturated colors in your images. This, however, shows skin tones that are "off" much more readily than a picture with low saturation. In these cases you may need to work twice as hard on your skin tones, as overly saturated skin is likely to look bad. You can solve this by locally desaturating your image where skin shows. For this some raw converters provide brushes, while Photoshop lets you mask a desaturation adjustment layer. Another important parameter to control saturation is vibrancy. This only affects colors with low saturation, and also has only a slight effect on skin tones. Compared to increasing saturation, vibrancy has a much more pleasant effect on skin tones.

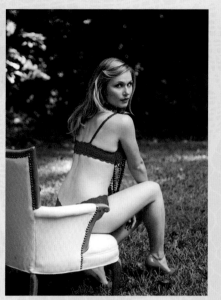

TOP, LEFT, AND BELOW: *Problems can arise when grass or foliage are predominant in a scene. The first image was white balanced more or less correctly; however, green light reflected from the grass onto the model's skin. Shifting the white balance tint control toward magenta improves the situation. Another way to deal with it is to add neutral light with either a flash or a reflector that brings in sunlight. The second image shows what can happen when auto white balance was used. The camera overcompensated for the green and turned the image magenta. This needs to be countered with a tint shift toward green.*

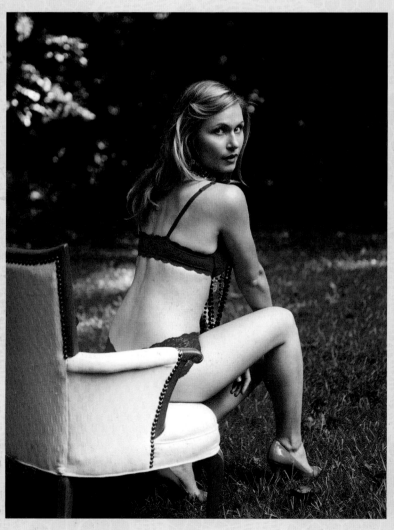

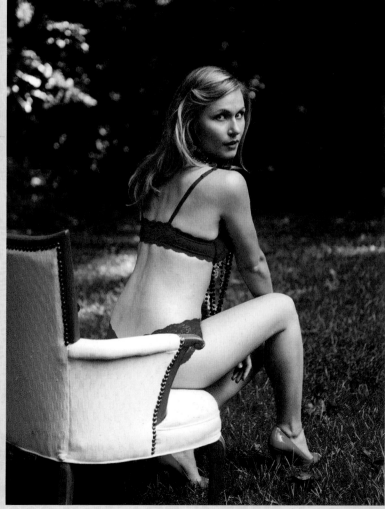

BELOW AND RIGHT: *Tungsten light threw a yellow cast on the subject, so the image had to be cooled down significantly by reducing the color temperature in the raw converter. White balance can be applied much more effectively and with less loss of image quality if the image is shot in raw format.*

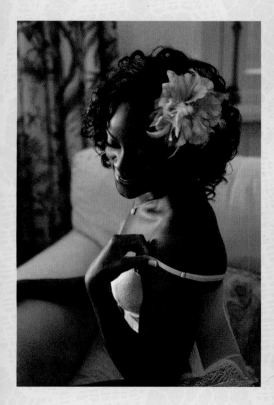

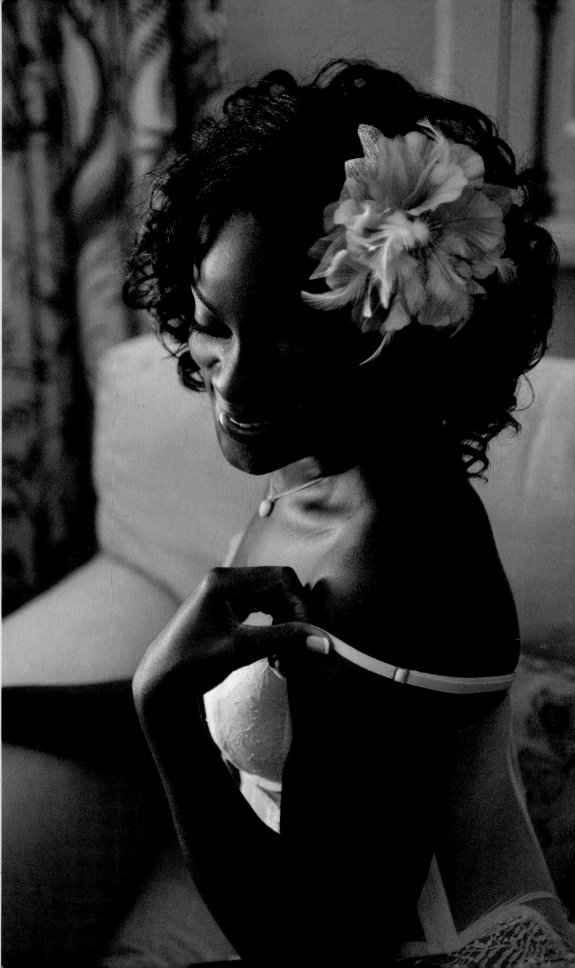

Facial blemishes

There are different kinds of blemishes—some that every client wants to have retouched, and some that are part of the face and the character and therefore might be rather left untouched. It's important not to make assumptions here. As ever, communication is key.

I F IN DOUBT, the best idea is to just ask which features a client likes about herself and which she wants hidden or retouched. Most clients will happily guide you there. Pimples almost always need to go; scars most likely, too. It gets more difficult with birthmarks—some women like them, some don't. Fading them instead of removing is often a good decision, especially when a birthmark shows up much more in one shot than it does in others.

Most kinds of facial blemishes are pretty easy to remove. This can be done in the processing stage with the spot removal tools that most workflow programs have. The most effective and time-efficient tools, however, are Photoshop's Healing Brush and Patch tools. They do an outstanding job 99 percent of the time. These tools preserve the original texture while removing a blemish, which is important so as not to overly smooth out the skin and make it look like plastic. The older Clone Stamp can do exactly this when a soft-edged brush is used,

and it is therefore less suitable for blemish removal. When you need to work extremely close to a contrast border such as eyes, hair, or mouth, the Healing Brush and Patch tool may pick up some of the adjacent section and produce a smear. In those cases using the Clone Stamp with a medium-hard edge is a better solution. When you use the Healing Brush it is best to set it to a rather hard edge, which makes it work more precisely.

One special situation where retouching facial blemishes can get extremely tedious is when they are visible behind a veil or some other texture or fabric that you have used as a prop. In those cases the best way to deal with it is to either copy and paste or to clone a clean portion of the texture to the given spot.

In addition to this, special skin-enhancing plug-ins can help you with removing blemishes. (See page 114.)

For working precisely, the latest versions of Photoshop (CS4 and newer) allow you to see what the Clone Stamp tool or Healing Brush tool will apply. This can be activated in the Clone Source panel under Show Overlay.

If you need to work on very complicated sections (blemishes under a veil or under other fabric come to mind), it is a good idea to do this on a new empty layer. Make sure your Clone or Heal tool is set to All Layers or Current & Below.

HEALING
BRUSH

RIGHT: *Photoshop with Healing Brush tool selected. If you turn Show Overlay on you can place your corrections very precisely.*

Lifts with Liquify

Nobody has a perfect and flawless shape, and even if your model comes close, there is always a pose that will show skin creases she will not be happy with. I want any retouching to be unobtrusive and not obvious. It's about making your models love their pictures and be happy with themselves.

Very often there are bulges and creases that clients are not even aware of, either because they are hard to see on themselves (do you know how the back of your arm looks?), or they just happen due to certain poses or how the light falls on the subject.

Liquify to the rescue! This is one of Photoshop's most powerful tools when it comes to beauty retouching, and if used skillfully and with care it can go unnoticed by your models.

The Liquify tool can be used with a mouse, but for more precision I recommend a graphic tablet. If you are just getting into the tool, make a copy of the layer you are working on and apply the Liquify tool to the new layer just to be sure. That way you can always mask the layer and brush in some of the original image. Make yourself familiar with the tool, how it reacts, and the different modes it offers.

The Forward Warp tool is the tool I use most. It softly shifts any border or area in the direction you push. Things you can correct this way are double chins, upper arms poking out (when leaned on), and creases in the belly. There is a big difference in having the tool's center directly over the line you want to move or slightly outside of it. Usually the latter gives you smoother results; having the tool directly over a line often yields dents that take additional work to fix. Start with a larger tool size and work your way down to a smaller size to refine and straighten out jiggly lines. The fastest way to change the tool's size is using the Photoshop standard keys. In addition with the shift key, the size changes in steps of twenty instead of two.

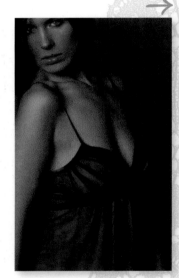

Before a breast lift.

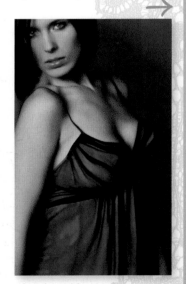

After a breast lift.

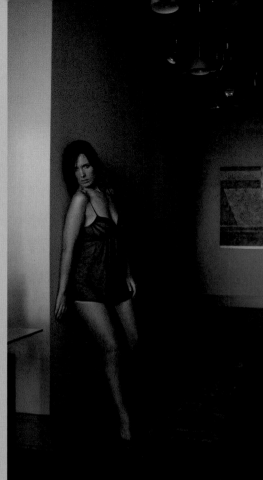

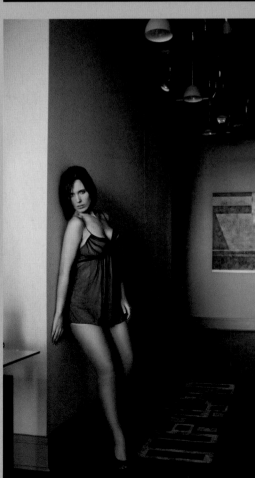

One of the biggest issues with using the Forward Warp tool is when nearby objects or body parts are affected in a noticeable way. There are several ways to deal with this. You can use a smaller tool size and meticulously deal with small portions one at a time, or, instead of dragging the tool perpendicularly in the direction you want to go, you can instead go in a parallel way. Or you can use the Freeze Mask tool, which lets you paint masks on sections you do not want altered. The last resort would be working on a separate layer and then copying or cloning back the parts that were erroneously moved.

Next are the Pucker and Bloat tool. These help you modify smaller, isolated sections. The Pucker tool will suck pixels toward the tool's center; the Bloat tool will push away pixels from the center. The tool's size determines the radius affected. My typical use for these tools is eyes, lips, breasts, nose, eyebrows, chin, and butt. The Pucker tool is also very useful for straightening out dents that result from using the Forward Warp tool. To do this I select a rather small tool size and then slowly draw over the edge that needs fixing. The Pucker tool will draw all surrounding pixels toward the line I am drawing.

Each Liquify mode has a set of parameters to customize it to the task at hand--Size, Density, and Pressure being the ones mostly used. There are numerous additional Liquify tools, but most of them are not very suitable for beauty retouching.

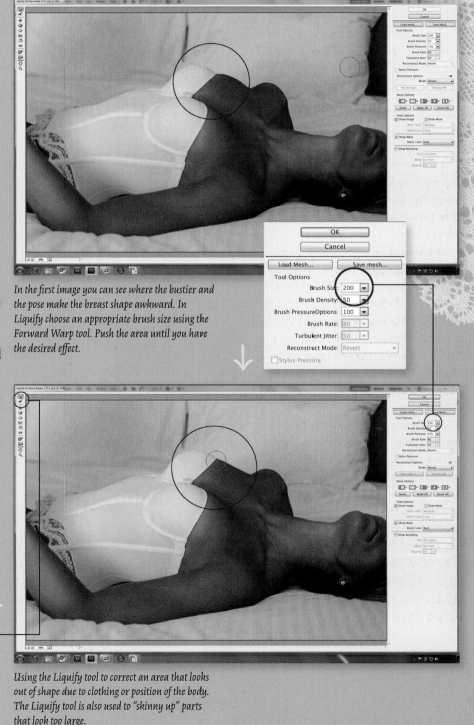

In the first image you can see where the bustier and the pose make the breast shape awkward. In Liquify choose an appropriate brush size using the Forward Warp tool. Push the area until you have the desired effect.

Using the Liquify tool to correct an area that looks out of shape due to clothing or position of the body. The Liquify tool is also used to "skinny up" parts that look too large.

Brightening eyes

Brightening the eyes gives a bit of a pop to the image for closer-up shots. Especially when your subject is looking at the camera, bright and intense eyes are mesmerizing and sensual and draw the viewer right into the photo.

THE FIRST STEPS in achieving this are outside of the digital darkroom—right at your shoot. Try to get light into your model's eyes. If light is hitting the iris, the color will be intensified, making the eyes stand out. Second, try to get a highlight in the eyes. It's that additional lively sparkle, and eyes without a highlight can look dull.

In post-production the quickest boost is simply brightening the eyes. This can be easily achieved with the Dodge tool in Photoshop or any lightening brush in your imaging software. Be sure to brighten only at 20 percent, as too much will give an unnatural look.

For close-ups you can use a more advanced technique that's used in beauty retouching. You boost brightness, saturation, and contrast and then burn the iris's outer edge. Let's go step by step in Photoshop:

LEFT: *Eyes without a highlight can look dull. They can be brightened using the Dodge tool or any lightening brush.*

RIGHT: *Here several enhancements have been made. The eye white has been cleaned up with Healing Brush and Clone Stamp tools (vessels, contact lens rim) and brightened with a Brightness/Contrast adjustment layer, then slightly desaturated with a Hue/Saturation adjustment layer.*

For the iris there is a Brightness/Contrast adjustment layer to brighten and add contrast, and a Hue/Saturation adjustment layer to increase saturation.

Lastly the dark rim around the iris has been darkened with a Brightness/Contrast adjustment layer. Do not go overboard with whitening or brightening the iris, especially when your catchlights are somewhat busy. This is a very obvious, often-seen mistake.

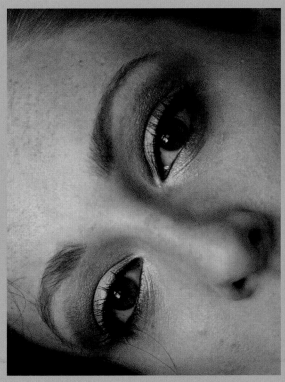

Before

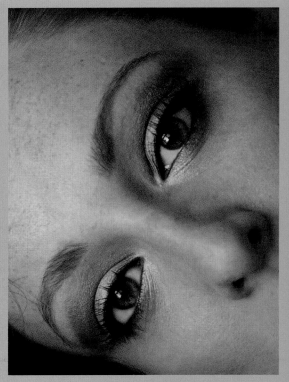

After

BRIGHTNESS, SATURATION AND CONTRAST

STEP 1
First create a Hue/Saturation adjustment layer. The latest versions of Photoshop (CS4 and newer) provide direct access with the Adjustments palette, while older versions have the adjustment layer button at the bottom of the Layers palette.

STEP 2
Increase saturation. Don't worry that your whole image is affected. We will deal with this in the next step.

STEP 3
The adjustment layer should already have a layer mask; that's the white field right of the layer's icon. Make sure it is selected (it has a double border). If not, click on it.

STEP 4
Invert the layer mask (Ctrl/Cmd-I or Menu>Image>Adjustments>Invert). Now none of your image is affected by the adjustment layer.

STEP 5
Select the Brush tool and white as Foreground Color. Set brush opacity to around 80 percent.

STEP 6
Now zoom in and paint over the iris (make sure your layer mask is still selected). You will see how the increased saturation shows up. Be careful with the pupils; they can get an unwanted color cast.

STEP 7
Now let's increase brightness and contrast. We will reuse the layer mask we already have. Cmd/Ctrl-click on the Hue/Saturation adjustment layer's mask. You will see the mask's marquee around the irises.

STEP 8
With this create a new Brightness/Contrast adjustment layer. It will use the active mask as its layer mask, again restricting it to the irises.

STEP 9
Now you can adjust brightness, contrast, and saturation to your liking, or change the adjustment layer's opacity.

To darken the rim of the iris, you can either use the Burn tool or, if you want more control, use another Brightness/Contrast adjustment layer. Don't overdo it! Some people already have those dark rims around their irises—no need to add it then. You can achieve similar results in Lightroom or Aperture using the selective brush tools there.

Hue/Saturation and Brightness/Contrast adjustment layers in Photoshop with their layer masks. By copying layer masks you already created you can save time and easily refine your result.

The layer palette for this. All adjustment layers were painted in with layer masks.

Plug-ins

Plug-ins enhance the functionality of your software. Photoshop, Lightroom, and Aperture all can make use of plug-ins. Some are simple one-trick ponies, others almost add on another powerful program. For boudoir photography the most useful plug-ins are retouching and skin-enhancing plug-ins, tonality plug-ins, and those helping you with workflow.

Contrary to photoshop actions or scripts, many plug-ins bring their own user interface to fully access their functionality. Plug-ins that provide tonalities can come in a huge variety. The three big providers of great plug-ins are Alien Skin, Nik, and onOne. The most universal are probably those plug-ins that provide tonalities, help with color correction, or simulate different film types (Exposure by Alien Skin, Color Efex by Nik, and PhotoTools and PhotoTune by onOne).

Two special contenders in this category are Nik's Viveza for selective color correction and their Silver Efex for black-and-white conversions. This is one of my favorites, and probably the best black-and-white tool the digital world has to offer—its black-and-white conversions are gorgeous and the film grain simulation gives a wonderful romantic look.

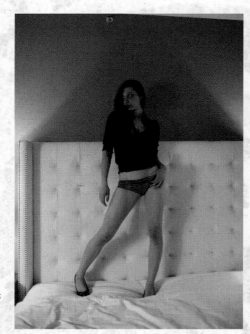

RIGHT: *Adding tonalities can really give a lift to an image.*

Sharpening (Nik Sharpener Pro), image enlargement (Alien Skin's Blow Up and onOne's Perfect Resize, formerly called Genuine Fractals), and noise reduction (Nik's Dfine) are other disciplines where plug-ins shine. Lastly there are more exotic plug-ins that nonetheless can enhance your work's look, including onOne's PhotoFrame (for adding frames and film borders) and their FocalPoint and Alien Skin's Bokeh (for selective focus and tilt lens effects). Human Software is another maker of a big selection of interesting plug-ins.

Aperture and Lightroom plug-ins can also help you with workflow-related tasks like creating web galleries and uploading to online galleries, blogs, photo-sharing sites, and social-media sites. They can also help you with housekeeping.

If you photograph boudoir on a frequent basis, any help with uploading photos is very welcome. As for online galleries, I use Pictage and Zenfolio, both of which have plug-ins available.

ABOVE: *AlienSkin's Bokeh adds all kind of focus effects like depth of field or tilt/shift lens emulation as well as vignettes, film grain, and more.*

LEFT: *Nik Color Efex is a universal plug-in for Photoshop, Aperture, and Lightroom.*

Smoothing the skin

Photoshop and similar imaging tools have long played their part in achieving flawless skin in editorial and advertising photography, and your subject will no doubt want that look. When photographing boudoir you need to do quite a lot of retouching because you have more skin showing in the images.

RETOUCHING SHOULD BE DONE in a less-is-more fashion to avoid making the client's skin look overworked. The last thing you want is for the client to look like plastic. There are many great products available for Photoshop to smooth the skin and get rid of blemishes in a quick and easy way. A few well known Photoshop skin smoothers are actions by Mama Shan such as Mama's Powder (see Web resources) and plug-ins. The two most popular plug-ins for skin enhancement are Imagenomic Portraiture and Portrait Professional (as of the writing of this book the latter will be available as an Aperture plug-in in its next version, version 10). Portrait Professional not only works on skin; it can also be used for shaping facial features. I personally use Portraiture for its ease of use and fast application.

Skin-enhancing software is great, but it can't do miracles—even though the manufacturers might want you to believe it can. In many cases some fine-tuning and further refinement with Photoshop's own tools is necessary. To effortlessly make skin look great for the proofing stage, however, these plug-ins are absolutely worth the money.

LEFT: *Smoothing the skin and keeping it looking natural.*

BELOW: *The skin has a glow without the waxy, articifial look indicative of too much processing.*

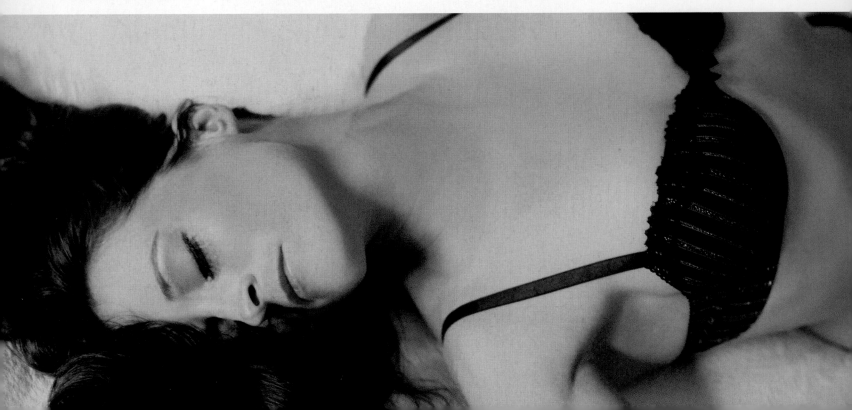

If you need to smooth out skin in a very controlled manner, Photoshop's Clone Stamp tool still is the tool of choice. You will need to change the default settings for the Clone Stamp tool in order for it to perform this task smoothly. My preferred settings are 0 percent Brush Hardness, 50–80 percent Opacity, and 50 percent Flow. You want to set a brush size as large as possible, and, with the Clone source close to where you brush, use even brush strokes to gradually soften the skin. Be careful in areas where the skin brightness changes to not brush away any light and shadow areas and lose the sculpting and three-dimensionality of your subject. This technique also works well for areas where the skin has an unwanted shine. Try to reduce it rather than completely remove it, or else the skin may end up looking dull and matte.

ABOVE: *Portrait Professional not only smooths skin, it can also reshape facial features.*

LEFT: *Imagenomic's Portraiture helps you get smooth skin fast—especially for the proofing stage it is an excellent tool.*

Another great tool for achieving even skin without losing texture is Photoshop's Patch tool. It will blend a source area with a destination area. To use it, select the tool, draw a marquee around the area you want fixed, and then, with Source set in the tool's settings, pull the area over the smoother skin you want to have applied. The tool gives you a real-time estimate of what is going to happen. Once you release the mouse, the source will be merged in. If you don't like the result, undo and pull the marquee to a new area.

A general rule is that skin can be pretty smooth as long as eyes, mouth, and hair are sharp and keep their detail. Too much contrast between smooth parts and overly sharp eyes and lips, however, can look very fake.

Before

After

STEP 1 — Choose the Quick Selection tool and highlight the leg area. Make sure you do only one body part at a time.

STEP 3 — Create a new layer copying the selected area using Layer>New Layer Via Copy. (Keyboard shortcut ⌘+J)

STEP 5 — Now choose the background layer again, and select everywhere except the area you were working on. Without feathering the selection, switch to the new layer created in step 3 and choose Layer>Layer Mask>Hide Selection. This eliminates the fuzziness around the softened skin layer.

STEP 2 — Using the Refine Edge tool, soften the edge of the selection inward by increasing the Feather slider. Here it is around 15 pixels.

STEP 4 — Apply a Gaussian blur to the new layer using Filter>Blur>Gaussian Blur. Apply a strong enough blur to eliminate all the skin blemishes, dragging the slider and watching the on-screen preview.

STEP 6 — Repeat for other areas (in this case the other leg), before applying a Vibrance adjustment layer to improve the skin tones.

Actions

Once you discover Photoshop actions you don't want to live without them! With actions, you can preserve and reuse any settings made in Photoshop. They also are a great way to get cool stuff that somebody else has come up with. Many are free, some can be purchased.

M Y PHOTOSHOP ACTIONS PALETTE IS HUGE! There are many little things that I saved this way—vignettes, black-and-white settings, split tones, sepia toning, and so much more. And then there is my vast collection of actions that I have bought. My all time favorites are the Kubota Actions and the Totally Rad Actions. Many of them are wonderful and not easy to come up with by yourself.

If you shoot JPEG and your workflow is mostly Photoshop-centered (I did that for a long time), then a great set of actions is invaluable. They help in color-balancing images that are too warm or cool, increasing or lowering exposure, and then giving the final touch to make your images look really great. I am often asked how I get my images to look so strong and make them pop. Most of all, of course, good lighting is necessary. But then just raising saturation and contrast won't do it. It will just make the photos blotchy, blow out the highlights, and block up the shadows. But there are some actions that perform true miracles. They work in a much more sophisticated manner on your photos to get you that high-end effect. Many of the currently sought-after retro looks are made with actions. Most places that sell actions have pretty good previews of what you can expect.

Once you have all your actions loaded in Photoshop, you might be overwhelmed because your actions palette is so big and difficult to navigate. To get organized, group your actions into folders that make sense to you. Then give them colors by double-clicking on an action beside its name. The color will not show up in the palette yet. You need to change from the default mode to Button Mode (this can be found in the palette's local menu). Now you will find all your actions as colored buttons, and you can even drag this palette to make it two or more rows wide. Now we're talking! You can also assign keyboard shortcuts to the actions you use the most.

Another great feature of actions is that you can look inside them and learn how the effect has been done. You will be surprised how much wizardry can be found in some of them!

Aperture and Lightroom have a similar feature: presets. Although presets cannot be as complicated and elaborate as actions are, they still help you minimize your workflow and get or preserve great settings.

Whereas actions are like a program that runs and executes many different things and can even select portions of the image, presets are merely a combination of settings. Again, there are great places to get presets, and many of the vendors of actions also offer presets. A great place to look is Preset Heaven (www.presetheaven.com), or just run an Internet search for Lightroom or Aperture presets.

But presets have a big advantage over actions, namely that you can modify any parameter later on—nothing is "set" into the image. Say, for example, you have a black-and-white preset, but it turns out that your photo is too contrasty after you applied it—simply lower the contrast, or select a different Tone Curve, and you're done. An action, once it's run, is done. You might need to apply additional settings (which can degrade your photo) or manipulate the action altogether.

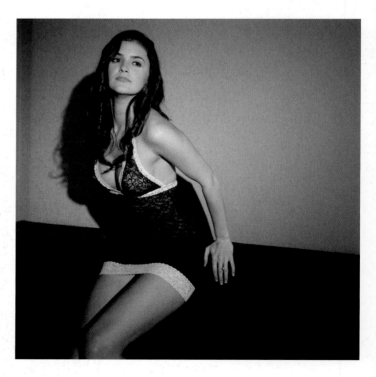

| HISTORY | ACTIONS | | ▸▸ ▾≡ |
|---|---|
| Over-X helper – overall | Over-X helper – paint in |
| Power Soft | Punch lite |
| Renaissance | Rich Shadows |
| Simple Soft (CS2) | Skin Powder Genie |
| Soft wash | Super Heroine (CS2) |
| Tea Stained | The Look |
| The Look with smooth (CS2) | The Look 2 |
| The Look 2 with smooth (... | Velveteen 23 (CS2) |
| Velveteen 23 reduced (CS2) | Velveteen 48 (CS2) |
| Velveteen 48 reduced (CS2) | Velveteen 65 (CS2) |
| Velveteen with Edge Dark (... | Velveteen Light (CS2) |
| Velveteen 48 & B&W Satin... | Velveteen sharper & BW Sa... |
| Velveteen adjuster | Wash Out |
| Detroit (B&W) | Lith-E-Yum! (B&W) |
| In Faux–Red (B&W) | Brooklyn (B&W) |
| Homestead (B&W) | Milk & Cookies(B&W) |
| BAMF 16–Bit (B&W) | BAMF 8–Bit (B&W) |
| Bullet Tooth | Sparta |
| Troy | Grandma's Tap Shoes |
| Pool Party | Acid Washed |
| Lux (soft) | Lux (hard) |
| Flare–Up (faded) | Flare Up (golden) |
| Get Faded (spring) | Get Faded 9summer) |
| Get Faded (autumn) | Get Faded (winter) |
| Get Faded (neutral) | A Better Web Sharpener |
| Straight Edge (Sharpen) | Slice Like A Ninja (Sharpen) |
| Cut Like A Razor Blade (Sh... | J–Sharp |
| Can–O–Whoopas (16–bit) | Can–O–Whoopas (8–bit) |
| Crush | Smooth–O–Matic |
| Select–O–Sharp | Select–O–Pop |
| De–Toner | Highlight Seperator |
| Shadow Seperator | Burn–Out |
| Punch Out!! | Claire–ify |
| Wish You Were Here... | Greetings From Paradise |
| Orange You Glad I Didn't S... | Red Channel Fix |
| Go With The Grain | P.O.S. Lens |
| f/zero | f/zero High Quality Conv... |
| f/zero Super HQ Conversion | f/zero Insane Quality Conv... |
| Beer Goggles | Dirt Bag (texture) |
| Dirty & Used Up (texture) | Dirt Lip (texture) |
| Dirty Diana (texture) | Dirty Birdie (texture) |
| Dirty Lovin (texture) | Pro Retouch |

▾ Navigator FIT FILL

▾ Presets +

▾ Lightroom Presets
- B&W Creative – Antique Gray...
- B&W Creative – Antique Light
- B&W Creative – Creamtone
- B&W Creative – Lyanotype
- B&W Creative – High Contrast
- B&W Creative – Lock 1
- B&W Creative – Lock 2
- B&W Creative – Lock 3
- B&W Creative – Lock 4
- B&W Creative – Low Contrasts
- B&W Creative – Selenium Tone
- B&W Creative – Sepia Tone
- B&W Filter – Blue Filter
- B&W Filter – Blue Hi-Contrast...
- B&W Filter – Green Filter
- B&W Filter – Infrared
- B&W Filter – Infrared Film Grain
- B&W Filter – Orange Filter
- B&W Filter – Red Filter
- B&W Filter – Red High
- Contrast...
- B&W Filter – Yellow Filter
- Color Creative – Aged Photo
- Color Creative – Bleach Bypass
- Color Creative – Cold Tone
- Color Creative – Color CP 1
- Color Creative – Color CP 2
- Color Creative – Color CP 3
- Color Creative – Direct Positive
- Color Creative – Old Polar
- Color Creative – Purple Glasses
- Color Creative – Yesteryear 1
- Color Creative – Yesteryear 2
- Creative – Split Tone 1
- Creative – Split Tone 2
- Creative – Split Tone 3
- Creative – Split Tone 4
- Edge Effects – PC Vignette 1
- Edge Effects – PC Vignette 2
- Edge Effects – Rounded Corn...

| Copy... | Paste |

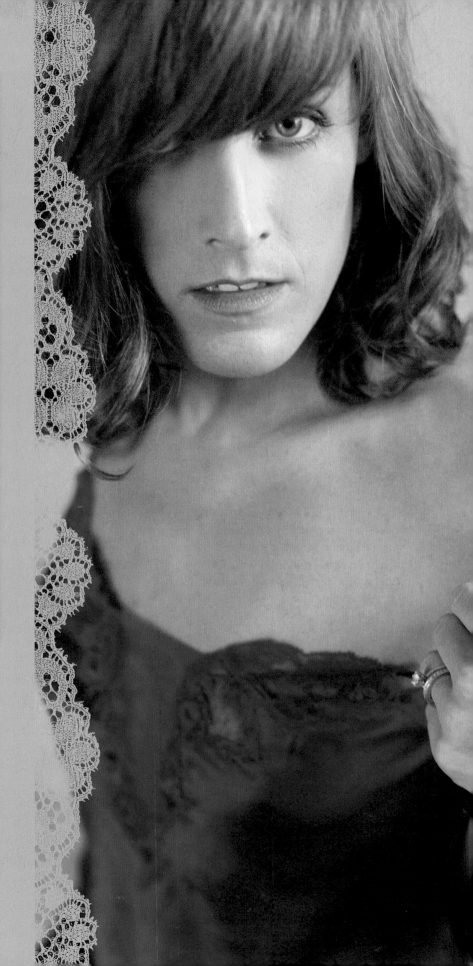

PRO TIP

Unfortunately, many presets out there have been made sloppily and they manipulate parameters that have nothing to do with the effect they are supposed to achieve. Parameters like sharpening, noise reduction, and others are usually nothing that most presets should alter, still they often do so. Be aware of this. For presets you use frequently in Lightroom you might want to resave the preset with just the parameters that matter for the desired result checked, and in Aperture eliminate the undesired parameters.

OPPOSITE: *A black-and-white retro feel can be quickly achieved with an action.*

ABOVE LEFT: *Part of my Photoshop action palette. I have it in Button mode with two columns and actions colorized to find them more easily.*

ABOVE: *Lightroom's preset palette.*

RIGHT: *An action can be used to saturate an image so it pops.*

Black and white

For quite a while now black-and-white photography has been having a renaissance, and even more so since digital photography allows us to decide to go black and white after the capture. All my clients love the black-and-white pictures they get. Whether soft and sensual or very dramatic, monochrome images have a timeless elegance to them.

I DON'T JUST RANDOMLY CHOOSE the images that will be black and white. Deciding what will look outstanding as a black-and-white image is a matter of experience. Images with high contrast, deep shadow, or extremely soft gradients and contrast are usually the ones that will do well. When I go through images from a shoot I can immediately spot the ones I will change to black and white.

There are many different techniques for converting to black and white, some highly scientific, some extremely simple. The key is finding a solution that yields great results each and every time without being overly complicated. All the popular raw converters—Aperture, Capture One, and Lightroom/Adobe Camera Raw—have modes that do exactly this.

 PRO TIP

Not every printer or lab will output a perfectly neutral black-and-white print, and slight color casts can be a result. To deal with this issue, I incorporate a slight sepia tint in all my black-and-white images. It's barely noticeable, but the printed result will either be exact and show the slight tint or be pretty neutral, but it will never go into any other unwanted tint.

Most of the time I do this in Lightroom with a Split Toning setting of Hue 45, Saturation 4 for both Highlights and Shadows. I have this setting incorporated into my standard black-and-white preset. Any other program you are using will be able to do something similar.

BELOW: *Black and white can be used to create a classy image.*

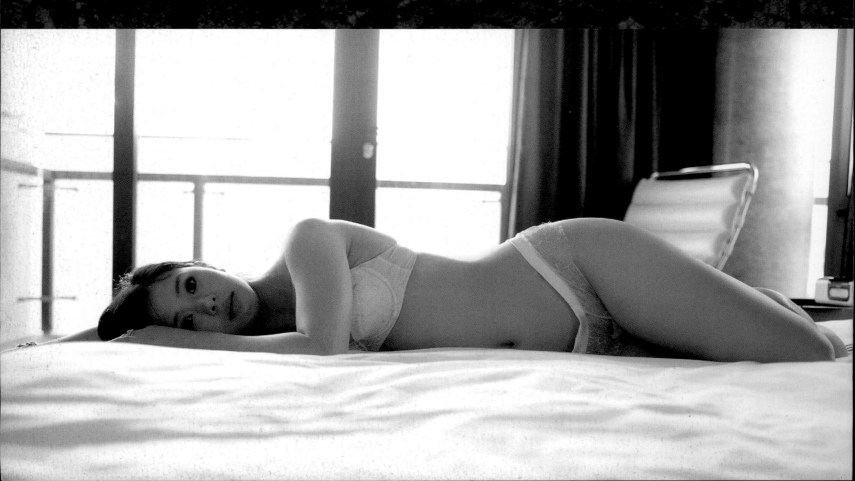

Often the first question I get about converting to black and white is "Should I white balance and color correct before turning to black and white?" With raw converters you have enough flexibility, so this is not necessary. Just apply your conversion preset and then, when you can see the result, make necessary changes.

I work in Adobe Lightroom and its Auto B&W yields very good results. Usually I apply a bit more contrast and a steeper curve (I use the Strong Contrast curve). Next comes a little secret trick: play with the White Balance sliders and then apply Auto in the B&W panel again. This has a dramatic effect on the overall appearance, and shifting the white balance Temp to very high values can brighten an originally too dark image much more effectively and with less noise than increasing the Exposure setting would.

If I want to refine even more, I go to the Black & White Mix section. It's not always easy to determine which slider will affect the desired tones in the image; the Target tool is of tremendous help here. To use it, click on the little bull's-eye symbol to the left of the sliders and then drag your mouse over the image portion you want altered. The respective slider(s) will then be adjusted.

If you want to create your black and whites in Photoshop, you can choose from a plethora of tools and techniques. I know that there are some extremely advanced and sophisticated ways to do it, but these should be left for gallery and competition prints, where the additional workload is justified. The best compromise of quality and efficiency is the Black & White adjustment layer. It offers a workflow very similar to what I have described for Lightroom, and it even offers a tint to be applied. Be aware that for Photoshop to create black and white, it makes sense to have color correction and white balance done first.

The one function I would not recommend for making good black-and-white images is Photoshop's Desaturate command. Too often it will yield only mediocre results without any means for you to correct it.

There are tons of black-and-white actions for Photoshop or presets for your favorite raw converter, and, since many of them are free, it's easy to experiment.

If I want to go above and beyond with a black-and-white image, my tool of choice is Nik Silver Efex. This is a plug-in for Photoshop, Aperture, or Lightroom, and its quality is unparalleled. It can simulate various film stocks, and the toning and grain effects are just plain gorgeous.

LEFT: *A Black & White adjustment layer in Photoshop. Note that you could even use a layer mask to control this layer's application. Lightroom's B&W palette has similar controls.*

BELOW: *Apple Aperture's Black & White brick.*

RIGHT: *Nik's Silver Efex, a plug-in for Photoshop, Aperture, and Lightroom, is one of the most capable black-and-white tools.*

Toning images and textures

Look at advertising and movies and you will find colors that are no longer a natural representation; instead there is a tonal range that creates emotion and enhances a scene's mood. Applying tonality in this way is also a great way to enhance your boudoir photographs.

MANY OF THE EXAMPLES we see today are based on effects from the film days. From sepia toning of black-and-white photos to cross-processing, all this and more can easily be accomplished with the correct software. Study how tonalities are applied. They can enhance what's already there, like toning a sunny scene even warmer or pronouncing the blue cast on a setting at dusk. Currently tonalities that give a retro effect are very popular. Faded colors, a yellow cast, and enhanced or minimized contrast give this feel.

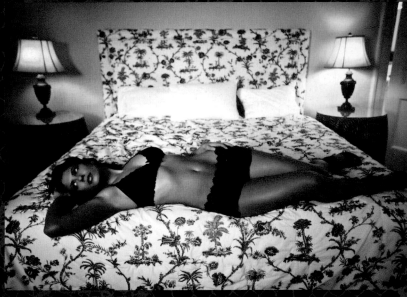

Some toning can make the image look more saturated.

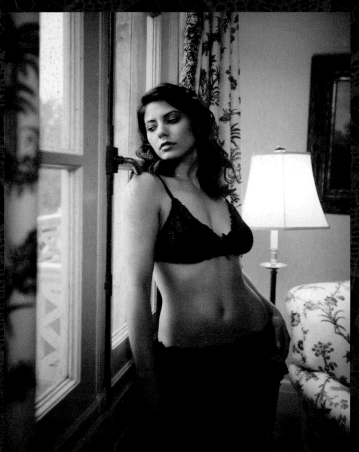

This photo has light toning to give it a vintage feel.

Toning may also be used for detail shots.

Many tonalities can be obtained as Photoshop actions, as plug-ins, or as presets for Lightroom or Aperture. Some are free, and some are packages you can buy, or you might want to go with your own creations. You can always preserve them as a Photoshop action or a preset in your workflow software.

White balance is the most basic way to tone an image, but it is rather crude. Most photo-editing software has a split-tone tool that allows you to apply different tones for the light and the dark parts of an image. Hue and saturation can be set as well as the split point for light and dark portions. This is a very effective tool that provides beautiful and subtle tonality. Try applying more saturation to the darker tones and only slight tonality to the highlights to achieve a well-rounded hue and less color distraction in the brighter skin tones. Split-toning is usually applied to black-and-white images, but it can look very nice on color images as well.

Contrast is another factor in great-looking tonalities. Desaturating images to a very low level and then increasing the contrast or the blacks leads to a look that is very popular in advertising.

Sepia toning.

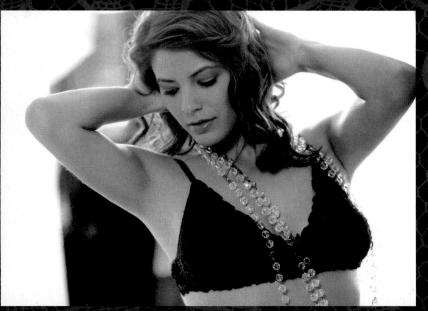

Slight desaturation.

Black and white.

To me, some photos scream for a special tonality, and others don't. This is a personal preference, and you might want to go with a more natural and realistic look for all your work or apply tonalities throughout your shoots. Be prepared for your clients to ask you to replicate what you show in your portfolio.

Keep an eye on how your applied tonality affects the skin tones. This is very subjective—you might be more or less tolerant of tonalities. However, there is always the possibility of applying less of the tonality to parts where skin shows.

While not exactly new inventions, textures and overlays have become a huge trend in the last few years. They can elevate an image to a whole new level, and give it a worn or very romantic look. A plethora of overlays is available online. Some are specifically sold as overlays; others are just images of textures and patterns. If you like to work with overlays, it's a good idea to photograph your own as well. Any little point-and-shoot camera will do for this. I have a whole collection of textures and patterns that I took over the years.

The easiest way to apply an overlay in Photoshop is to create a new layer for the photo you are working on. Then copy your overlay texture or pattern into this layer and set the layer blending mode to overlay. Adjust its layer transparency to taste, and also experiment with other blending modes. In most cases I add a mask to the texture layer and mask out the texture where my model is placed. Texture on skin and especially on the face usually looks rather unflattering.

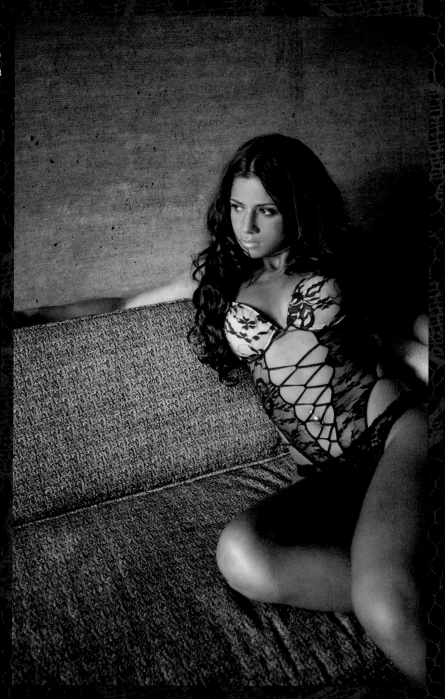

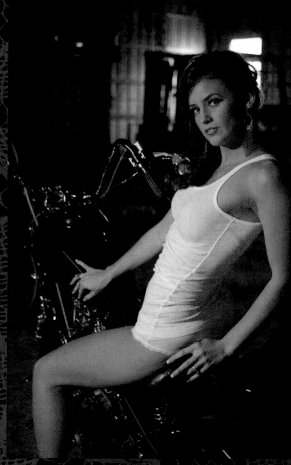

ABOVE, RIGHT, AND OPPOSITE: *Examples of textures.*

If you add toning and textures to your images, use these techniques on only 20 percent of the proofing. You will want 80 percent of your images to be true color mixed with black and white. Not all clients will want all of their images with tonalities.

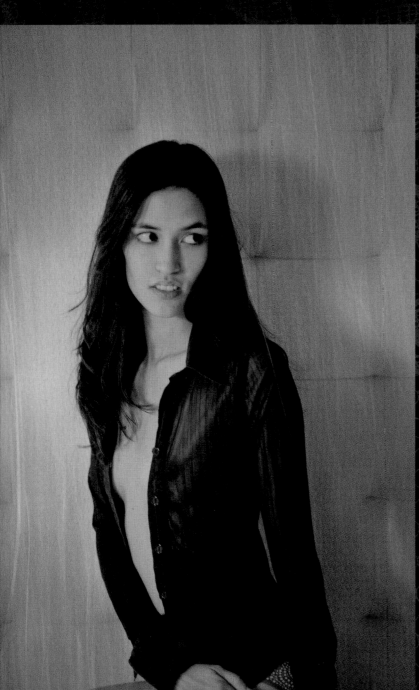

Split Toning ▼

Highlights

Hue		45
Saturation		4
Balance		0

Shadows

Hue		45
Saturation		30

Duotone Options

Preset: 478 brown (100%) bl 1 ⬆️⬇️ ≣ OK

Type: Duotone ⬆️⬇️ Cancel

☑️ Preview

Ink 1: Black

Ink 2: PANTONE 478 CVC

Ink 3:

Ink 4:

Overprint Colors...

TOP: *Lightroom's Split Toning palette. Don't forget to play with the balance slider and try different saturations for Highlights and Shadows.*

ABOVE: *Photoshop's Duotone options. To get there you first need to convert your image to grayscale, then to duotone. This tool provides endless settings since it offers up to four color channels, which all can be controlled by curves. If you need the highest subtlety in split tone, you will find it here.*

Outsourcing

If you shoot a lot, maybe even professionally, you might come to a point where post-production takes up too much time and keeps you from photographing and liaising with client contacts and various other sides of your business. This might be the time when you think of outsourcing.

MANY SERVICE PROVIDERS offer workflow solutions of all different kinds. From selection of your images to color correction and raw processing, from adding tonalities and a specific look to retouching, pretty much any task you want to outsource is offered. Many companies also order album design services, uploading, and even print fulfillment.

Most photographers have a hard time letting others work on their pictures (myself included!), so the first important step is trusting the people who do the job. At the same time it is crucial that the company of your choice can accomplish the look you are after. The first step in establishing a relationship with a service provider is nailing down your vision. First, take a look at sample images on their website, preferably before-and-after images. Of course this is only a first impression. They may let you select from a choice of looks to find the one you prefer—warmer or cooler appearance, high contrast or softer, neutral black and whites or mostly sepia, much tonality and actions applied, or a straight look. Make sure you can communicate well with them and that they respond to your requests in an acceptable time frame. Also find out whether their turnaround times are what you are expecting. If retouching is a service you want done, make sure they have experience with it, and let them know what and how much you want done.

Lastly, talk to the companies you plan on using and find out whether they are happy with working on boudoir photography. Not everyone is.

The next step is having them work on the images from one or two shoots, reviewing the results and communicating to fine-tune. This again will show their level of communication and their willingness to adjust to your liking. If you encounter any resistance there, skip this company and find another, because you don't want them to create a look you don't like.

Before you start sending off your work you need to figure out how your images get to the company and how they come back. If you have an Internet connection with a reasonably fast upload speed, you may just upload and download everything. The problem usually is that you need to upload raw files, which are very big, and very often the upload speed for Internet connections is slower than the download speed. Getting images back is easier—they usually are JPEGs and download is fast. Luckily boudoir shoots usually don't consist of an outrageously high number of images, so even with a slower Internet connection it can work for you. (If you are dealing with weddings, that's another story.)

If uploading is not an option for you, just send CDs or DVDs. It will take longer, but your Internet connection won't constantly be blocked. Usually you can decide on how to get your stuff to the company and how you get it back.

Finally, of course, their prices need to be right, but you might be surprised how reasonable these services usually are. Consider how much time the services can save you—they might even improve your image quality.

Another clever option (the one I use) is asking for XPM sidecar files back. XMP files (unfortunately!) are used only by Adobe products—Adobe Camera Raw and Lightroom. They contain all the changes and settings that were made to the images, and if you re-import the XMP files you got back from your service provider, all these settings will be applied to your raw files. XMP files are tiny, so small that even several hundred can easily be emailed when combined in a Zip or StuffIt archive. Another advantage of this system is that I can always come back and further fine-tune and tweak the results I got back.

Of course, this system only works for what can be done in those raw converters. If you have the company retouch your photos, they will need to send back finished images as JPEGs or TIFFs, or in Photoshop's PSD format.

RIGHT: This is how Adobe Camera Raw (ACR) opens my raw file directly out of the camera. I had sent a DVD with all the raw files of this job to my processing company (Lavalu) and got back a small folder with all the XMP sidecar files. After I dropped the XMPs into my raw image folder, I could see (and modify) their processing in ACR. It would work just the same way in Lightroom.

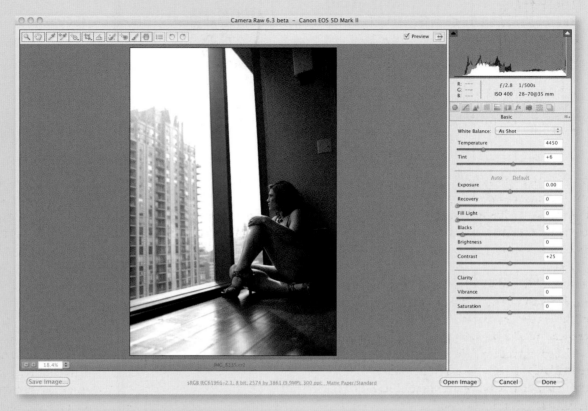

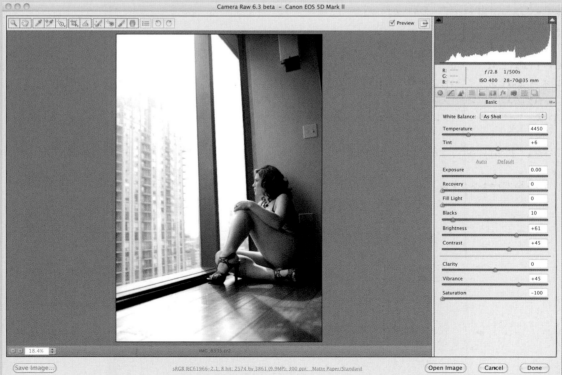

Presentation

❧❧❧❧❧❧❧❧

You can be the planet's greatest photographer, but if you do not showcase your work well, the world won't know. If you are working for clients, this holds true even more so. Presenting your work well is like a chef putting exquisite food on beautiful china. Show your work in a way that puts you in a professional yet artistic light. There are great products out there—I always strive to find new ways to present my work and new products to sell.

Confidentiality

It is important to seek out trustworthy professional services when hiring a business to handle post-processing, retouching, and printing. If possible, it is helpful to use one company for all processes.

ASK THE COMPANY ABOUT THEIR POLICIES and comfort levels regarding the type of photography they are handling. If possible, create a confidentiality agreement with the business to ensure your rights to the images and to avoid improper use. It is very important for clients' images to remain private to protect both their privacy and your reputation as a business. If a company you are using for post-processing or printing should use the images in a public way, this could leave you liable if the client decided to sue. Some clients may have a high-profile job or be a public figure and not want the images to become public. You should keep all images private unless the client gives you written consent to use the images for your website, promotions, blog, or anywhere else.

RIGHT: *Having a professional and responsible company provide your albums is vital for presenting your client with a high-quality product.*

PRO TIP

Search for the best companies to use online for your processing, printing, and album binding. There are many, many choices, so be sure to ask lots of questions before you decide on one vendor to use. Also make sure they offer the quality and the service you expect.

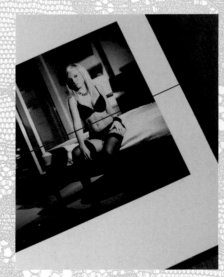

Permissions and privacy

It is of utmost importance to establish a professional standard when working with models and boudoir photography. All photographers want to show their work, but first they must gain permission from the client.

HAVE THE CLIENT SIGN a model release indicating she is giving her permission for you to show and use the photos. Next have her sign a privacy agreement indicating her preference on how the photos can be used. It is best if she agrees to allow the photos to be used in any capacity, because the photographer has no limit to what degree they display the work on their website, promotional and marketing materials, or social media sites. Because of the client's personal preference, profession, or comfort level, she may opt to allow use of the photos only in certain ways. Be sure that the signatures of both the client and the photographer as well as the date are included in the document. Having these policies in place displays professionalism and shows the client that you have thought through the process of protecting her.

PRO TIP

Bring any documents with you to the shoot that you want your client to sign. It is easier to have her fill it out then rather than later.

Model Release Form

Section 1:1._____ (model name)
Do hereby give [Photographer Name],[Business name]. Inc and his/her assigns, licenses and legal representatives the irrevocable right to use my images, picture, portrait or photographs in all forms of media and/or composite representatives for advertising, trade or any lawful purpose and I waive any right to inspect or approve any finished product, including written copy that may be created in connection therewith.

Section 2; I am 18 years or older. I have read this release and am fully familiar with its contents.

(Please Print)
Name_____ Cell phone_____
Home phone_____
Address_____ Date_____
Email_____
Signed_____

All fields information must be completed.

[Company Name]
[Address]
[Website]
[Phone]

Please Read carefully
Privacy Policy

[Business name] understands the importance of your personal privacy, and wants to be certain that we have permission to use or not use images with the expressly given consent of the client.
All measures will be taken to protect the confidentiality of the professional images taken. The privacy policy of [Business name] is set forth below.

When you are photographed by [Business name], certain measures will be taken to keep your photos private. Images will be placed on a professional password protected website for you to view.
If you decide to decline to share your images on the [Business Name] website or other marketing, please be assured your images will be kept private.

Privacy ~Permissions:

Section 1; Initial one:
Description of images for use:
__I trust you to only use tasteful images
__share all images
__share images with no face
__do not share any images
__marketing materials

Section 2: Initial all that apply:
Images may be used for:
__blog
__website
__sample albums
__sample display

Section 3: I, (full name)_____, Do hereby give [Business name], and his/her assigns, licenses and legal representatives the irrevocable right to use my images as stated in section 1 and 2.

Section 4: I am 18 years or older. I have read this release and am fully familiar with it's contents.

(Please Print) Name_____
Home phone_____ Cell phone_____
Address_____
Email_____
Signed_____ Date_____

All fields of information in sections 1, 2, 3, and 4 must be completed.

[Company Name]
[Address]
Website]
[Phone]

LEFT: *Model release standard.*

ABOVE: *Privacy policy model release.*

Printing

Most clients these days want a CD/DVD with the images on it, but there are many more beautiful products to offer. This can be another way of standing out from the crowd—and adding some additional revenue.

Before the first print leaves your hands, you need to make sure that your prints look good, are neither too bright nor too dark, and that the color quality and the skin tones are spot on. Get some test prints from the labs you plan to order from, as well as samples from the manufacturers of any albums you want to offer. In many cases test prints are offered as a free service. If the prints you receive differ strongly from what you expected, go back and revise your monitor's calibration.

Use professional labs that guarantee consistent output quality and fast turnaround. Most of them nowadays use an online order system and mail delivery. The main problem is that they often apply some auto corrections that can mess up your precorrected images. So make sure the lab you choose will run your image files unaltered. Most labs need your image files to be in sRGB color space. To avoid any unwanted results, check your settings in Photoshop or any program you use to output the images. Consumer labs in pharmacies and the like should not be an option, as their quality is not very consistent.

Albums are probably the best product to go with a boudoir shoot. Many album companies have adjusted to contemporary taste with album styles far beyond the simple black leather album, with multi-material covers and exciting designs. In particular, smaller-sized albums (like 5×7-inch or 8×8-inch albums) are popular for boudoir photography since most people do not want to have a huge book of their boudoir photos on their coffee table. You can either have the album company print everything and bind it to an album or get a peel-and-stick album into which you mount the prints yourself.

ABOVE: *Split-cover option, also known as two tone.*

ABOVE AND RIGHT: *Unique leather cover options.*

Whatever you plan to offer, the major rule is "show what you want to sell." Most people have a hard time imagining something they are not able to see—and they won't buy what they can't imagine. I have a few beautiful sample books made; all album companies offer steep discounts for those, and I show them at every shoot. This way the model will have an idea of the quality I am offering, and I can explain options. Once they see these beautiful samples, it's very likely that they will get a bigger book than they had planned.

Little accordion folios are an extremely popular product to showcase boudoir photos—their covers come in nice colored fabric or with a print on it. Because of their size—around 2.5×3.5 inches—they are easy to carry in a purse and your model can proudly show her beautiful photos wherever she goes. Many manufacturers offer these little folios in sets of three at a very attractive price.

◣ PRO TIP

If you have a professional-grade printer and decide on printing in-house it is necessary to check that your printer is capable of producing archive-quality prints that do not deteriorate after your clients receive them. You should also make sure that you can download profiles for all the papers you intend to run in your printer, or you need to get the necessary hardware and software to create your own profiles. Without this it is unlikely that your prints will turn out as expected. Laminating can dramatically increase print durability. Many printers can also print on CDs and DVDs, which is a great way to style an otherwise rather bland product. If I sell a CD or DVD, I put it in a nice case. Some album manufacturers offer cases with a cover similar to the chosen album covers. There are also cases available that you can have a picture printed on.

Digital distribution

After their session your models can't wait to see their photos! Digital capture has dramatically changed the way images get to your clients. In many cases they not only want prints or a book, but also the image files.

Besides the question of whether you want to release image files, and when, there's also the question of how.

The decision of whether to release image files to clients greatly depends on your own way of selling and also on the market you are in. Some clients are totally happy with getting only tangible products like prints and books, others insist on a disk. Giving the option of getting JPEGs right away may cut into print sales if they are part of your business model, so you might decide on releasing them at a later point or getting compensated for the files sufficiently.

Generally there are two ways of distributing your files: on storage media (usually CD or DVD) or in an online gallery. For most clients I typically do both. The CD/DVD is their end product, the finished image files for the model to keep. To make it an exciting product, I use printable CDs or DVDs and I print one of their pictures on the disk. I also order some beautiful printed CD cases. A CD or DVD can be so much more than a bland silver disk, written on with permanent marker and then put into a cheap paper sleeve or a boring jewel case (which breaks the instant it is dropped). My clients are absolutely blown away when they get these products.

Of course you can come up with many other ways to give the image files as an exciting product: USB sticks with your logo printed on it or even an (engraved!) iPod touch or iPad with their images on it, ready to view.

I use online galleries mostly for my clients to select the images they want to order as prints or that should go in their books. However, "online gallery" is almost too generic a term for the different kinds of services available. It can be a simple HTML gallery, uploaded by you to your own web server, or any of the numerous gallery systems like Flickr or even Facebook galleries. But beware! The privacy of your clients must always come first—consider this with any of the publicly accessible systems.

Better suited for the job are systems that provide password-protected galleries and sometimes offer a wide array of additional services like print fulfillment or even promotional tools. Most of them are available at a monthly or annual subscription basis, ranging from very affordable—like Zenfolio or SmugMug—to higher priced options like Red Cart, PicPick, and Pictage, to name a few. It all depends on the range of services and the features they offer. So consider your immediate requirements and also your requirements in the near term and future—it's not an easy task migrating to a different gallery system. How many galleries do you plan on hosting? How much storage space will you need? How easy and straightforward is use, navigation, and ordering, not only for you, but foremost for your visitors? Do you want print fulfillment and selling via the gallery? How good is security and privacy? Is uploading easy, or can you also send in disks? Are there any complaints out there concerning reliability and availability of the service? Many of these services have user forums where you can learn more about this. Other features are image protection from unauthorized downloading, watermarking, and also provision of downloads.

Once the images are uploaded, the process of releasing them to your clients is another process that can range from simply sending them a link and a password to a fully automated procedure where your clients can take part in releasing it to other viewers.

Also check with the provider whether they are happy with hosting boudoir photography—not everybody is.

PRO TIP

If you are using online galleries on a frequent basis, it's a good idea to look for means to make the upload process as painless as possible. Many systems feature an advanced uploader and might even offer plug-ins for one of the programs you already use, like Aperture or Lightroom.

RIGHT: *On my website the client can access their online gallery, which is password-protected and non-searchable to protect their privacy.*

Some of these systems even let you apply your own branding to make visiting these galleries an experience similar to visiting your website and emulating a look your clients are already familiar with. More advanced systems also offer analysis tools that show you how many visits a gallery has and what products were sold. If you are selling from the online gallery, you might also want means for a coupon and rebate system.

Turning professional

Once you have provided beautiful boudoir pictures to several women, you may have many more asking you to do the same for them. At that point you might consider charging for the service and making it partly or completely your income.

I T IS VERY IMPORTANT TO CREATE a continuous flow of inquiries and do so before your number of inquiries starts to decrease. Marketing is the keyword here, and word-of-mouth referrals are among the strongest source for clients. The key is having past clients as well as friends and acquaintances spread the word about what you do. If you photograph in any other genre, be it portraits or weddings, let those clients know that you offer boudoir photography as well.

Creating an effective marketing campaign for your boudoir business is simple. Printed marketing materials and viral/online marketing go hand in hand and can complement each other. Boudoir photography is a popular style of portraiture for women of all ages and sizes, single or married, so there is a wide target audience you can address.

The center of your marketing efforts should be a beautiful website and/or blog. Templates are available that help you get up and running quickly without it looking homemade. You want to present photography that invites potential clients to book with you, and your Web presence needs to go along with this.

Get your sexy on...

www.coutureboudoir.com

ABOVE AND OPPOSITE: *Marketing material.*

Choose marketing materials that will work for your company and promise a sensible return for the money you spend. A full-page magazine ad for several thousands of dollars may look great, but will it get you enough clients to justify the cost? There are many other options, one being mailers that you can mail to potential clients or to put in venues that women frequent.

Here is a list of places you may be able to place your marketing materials:

* Beauty salon
* Spa
* Yoga studio
* Gym
* Nail salon
* Tanning salon
* Doctor's office
* Plastic surgeon's office
* Dance studio
* Boutique dress shop
* Lingerie shop
* Bridal shop
* Florist

The list of possibilities is endless and can include any place you can think of where someone may pick up one of your mailers. Putting your materials in front of the public will generate more portrait business for your company in a short amount of time.

Viral marketing on Facebook, Twitter, and other social media is another great way to put your company name in front of thousands of potential clients.

Create a Facebook fan page with your company brand and ask current and past clients to join. The more people you have join your fan page, the more likely it is that potential clients will see your work.

Here are some sample boudoir mailers to give you an idea of how you can showcase your work and get it in front of potential clients.

When creating a marketing piece for boudoir, pick images that will appeal to your target market. If you are putting mailers in a bridal boutique, you will want to have an image such as a bride in her bridal lingerie and veil. For a lingerie shop, you may want to include an image of a body shot or an image that showcases lingerie.

Pricing

Pricing your sessions should reflect the quality and service you are providing to your client. Decide what you want your profit to be and consider all the involved costs before determining your overall session fee.

HERE ARE SOME KEY FACTORS you should consider when coming up with your pricing: If you are shooting in studio, what is your overhead cost to maintain your establishment? If you are shooting on location, are you including the location fee, or will you have the client pay the location fee? Your equipment and insurance should be factored in.

One of the biggest things is your time—not only for the session but for keeping your business running (advertising, accounting, office supplies) and all the post-production afterward. You need to price yourself for profit. You need to research your numbers and know what the cost of each shoot is for you. Add 35 percent to that for your taxes—yes, you have to pay taxes if you are a professional photographer. Add in your expenses, and this means for everything— gas, props, locations—and don't forget the cost of goods sold such as albums, reprints, folios, and calendars. How much is your marketing? How much is your post-production costing? If you are not outsourcing, how much time do you spend per job retouching? If you spend three hours, how much is your time worth? Do you want to make $10 or $50 an hour? All of these things need to be factored in when determining your pricing.

Sure, everyone has to start somewhere, but if you start low it will take you a long time to crawl up the ladder to make more. When it comes down to it, so many photographers are only making minimum wage, and most do not even realize because they never look at the actual costs. They do a shoot for $200 and think, "Wow, I just made $200 for two hours of shooting!" Well, what about all the other work and expenses? I can even imagine some people are not making any money at all, and shooting boudoir is actually costing them money. The key to success in the photography business is knowing your bottom line. Don't start out to fail—be smart and price yourself to make a profit.

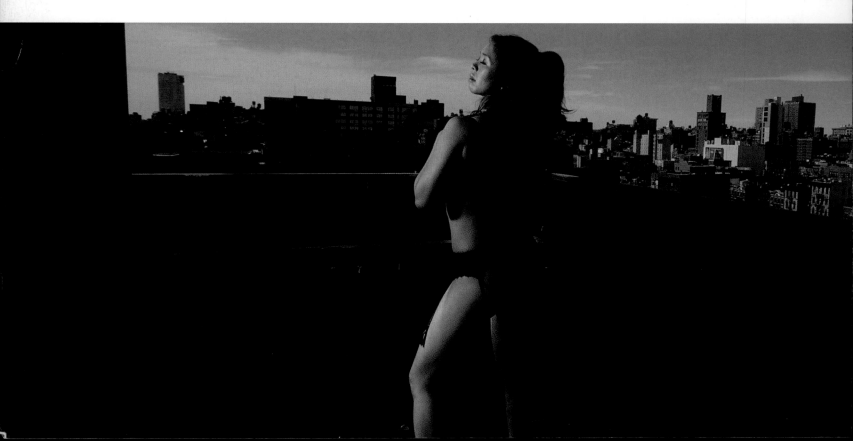

Do not sell yourself short. Always charge for your work. Once you have a portfolio, there will be no reason why you should not charge your regular rates for what you offer. Know your bottom line and multiply it by three to at least make a fair profit. There is a saying: "Shoot free or full price—never shoot cheap." I can't say that this is 100 percent right, but it is certainly something to think about.

The most common mistake new photographers make is underpricing their services. This worksheet will help you understand your cost to do business and help you to create pricing that will make your business profitable. I see it so often: photographers think what they just got paid for a shoot is the money they make. In reality they might have lost some money.

This is just a simplified breakdown and if you want to get serious with running your business, you should consider a business class. You need to compare what you get paid to how much it costs you to run your business, including the costs of all the goods that need to be bought for clients. The longer you have been doing this, the more accurate the numbers will get. It's all an average, never forget that there are busy months and months where you have way less assignments, because of seasonal waves or because you went on a vacation.

BELOW: *A shoot can be expensive. Make sure you have determined the fees, location rental, insurance, and other expenses, as well as your time.*

RIGHT: *A sample pricing template. Make sure to cover all your costs when determining your pricing, and aim to make a profit.*

Pricing Worksheet

Fixed Fees: $.
Studio rent
(Even if you are working from your home office you are still paying
to work there—include these costs even if it is just a fraction of your $.
monthly bills.) $.
Utilities $.
Marketing $.
Memberships (such as WPPI DWF, PPA—see web links in reference) $.
Staff $.
Props $.
Other $.
Location fee $.
Gas $.
Parking $.
Products $
Processing
Fixed Fees Total

Non Standard Fees: $.
Training, literature $.
Office Supply $.
Equipment cost (camera gear, computer hard and software) $.
Props $.
Others
Non Standard Fees Total

Per Session Fees $.
Location Fee $.
Gas $.
Parking $.
Stylist $.
Production of goods (albums, prints, CDs, and so on)
Processing

Style Gallery

MANY GENRES OF PHOTOGRAPHY depict the female form. Each has its own style that emphasizes an artful way to showcase women's sensuality. Years and decades of inspiration, maturing, and interacting with commerce, advertising, and the other arts have formed and defined different styles. The lines are not always drawn sharply, and sometimes it is hard to put a photographer's work in any single definition. Let other styles be an inspiration for your own work!

Boudoir

Boudoir today is the new style of sexy lingerie photography for the average consumer. No longer is it just meant for the Victoria's Secret model or the movie star posing for a high-fashion magazine. Nowadays any woman may have beautiful, sexy portraits taken in a modern way.

CONTEMPORARY BOUDOIR PHOTOGRAPHY has evolved from lingerie fashion photography, commercial advertising photography, casual lifestyle photography, as well as classical art. Long gone are the boundaries of small studios; incorporating beautiful or exotic locations and themes enriches boudoir with elegance and excitement. The tastefulness that most boudoir photography features has brought this style into the view of the wider public and onto many ordinary women's wishlists. Boudoir has fast become a sought-after genre of lingerie photography—more and more women want to have photographs taken in the boudoir fashion.

The way boudoir photography showcases a woman's sensuality is as varied and dynamic as the women being photographed.

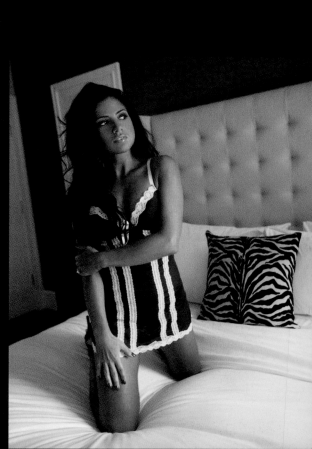

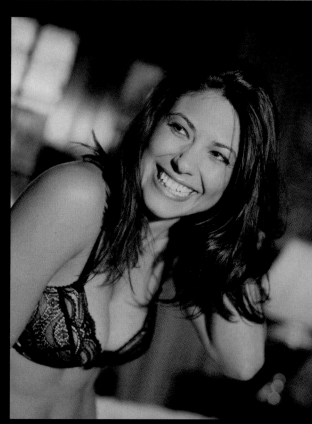

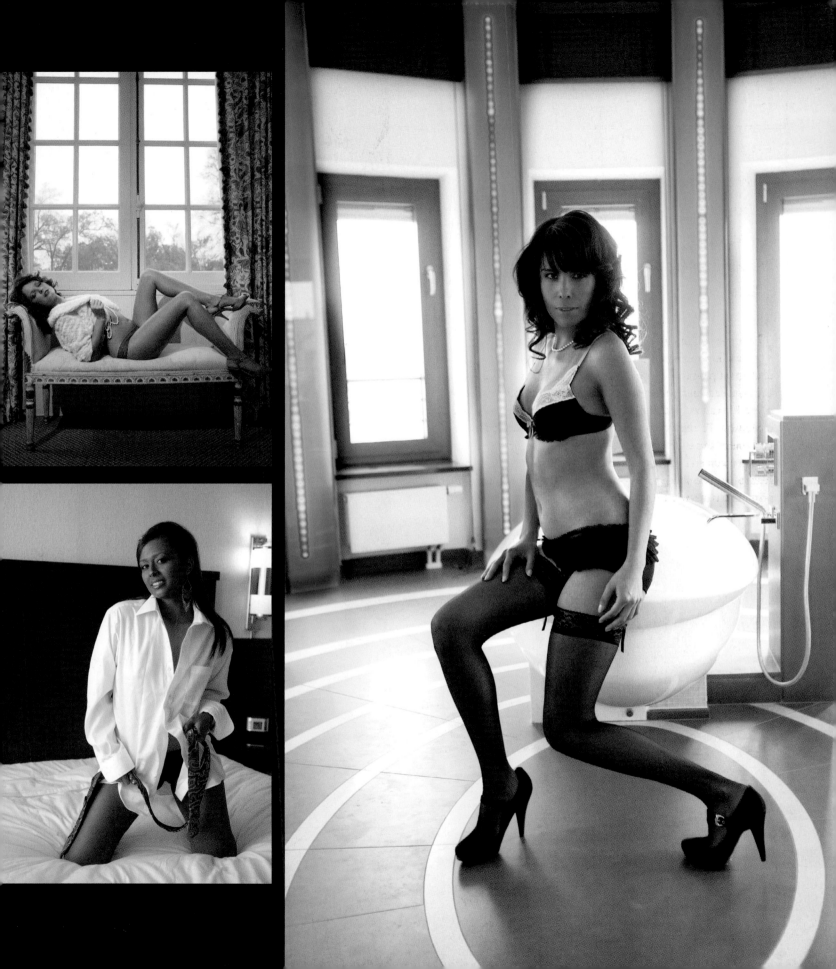

Glamour

While boudoir is considered as being more modern and tasteful, glamour is still very popular among clients today. Standards of glamour photography have changed over time, reflecting changes in social acceptance.

I N THE EARLY 1920S, photographers like Ruth Harriet Louise and George Hurrell photographed celebrities to glamorize their stature by using lighting techniques to develop dramatic effects.

Glamour typically features models wearing feather boas or having more standard, traditional poses. Glamour photography is different from other genres in that it emphasizes the model rather than the fashion or environment, and it usually does not imply nudity. Typically the sexuality of the model plays a fundamental role in glamour, whereas boudoir photography is a combination of showcasing the sensuality and lifestyle of the subject. But there are other details that further separate the two. Glamour photography is much more related to soft focus and diffused lighting and is mostly taken in studio. Today, glamour is often thought by photographers as the old style of boudoir.

RIGHT: *A feather boa shot with dark backdrop mimics the early style of glamour photography.*

OPPOSITE TOP AND BOTTOM: *Studio lighting, as well as props such as whips and feather boas, are much more common in glamour photography than boudoir.*

OPPOSITE RIGHT: *The focus of a typical glamour shot will be the model's body, emphasizing her sexuality.*

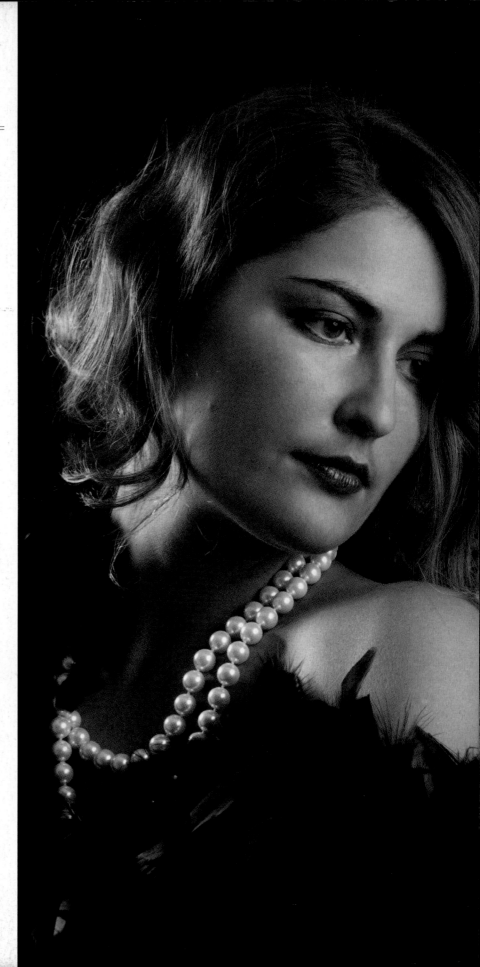

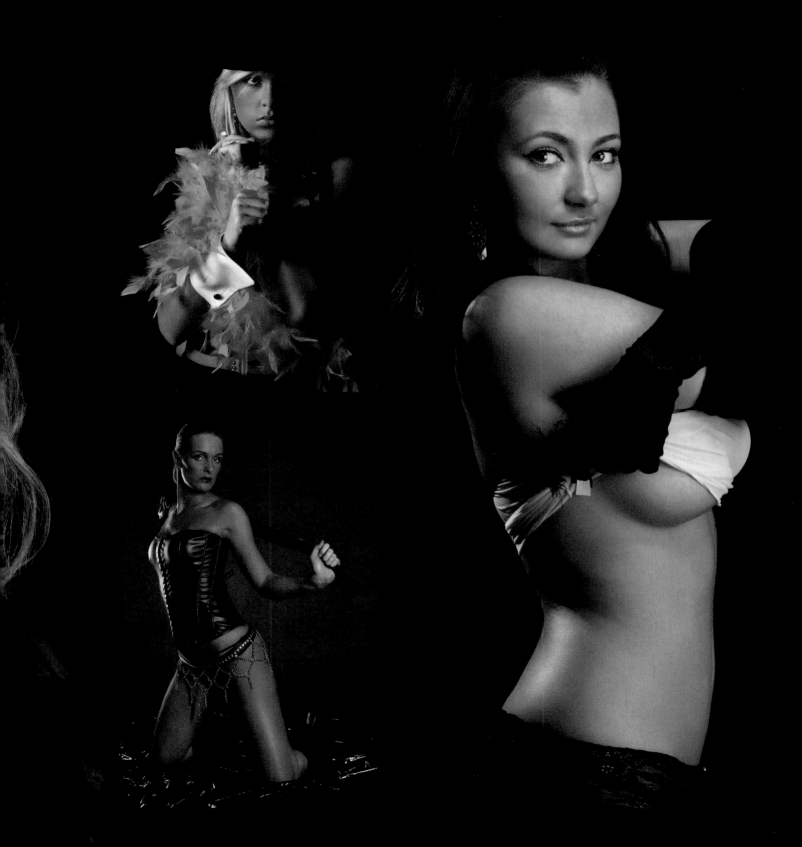

Pinup

Pinup photography began to gain popularity during World War II, when pictures of scantily clad movie stars were extremely popular among US servicemen. These men pinned painted calendars, advertisements, and photos on their locker doors, and large-scale pinup images adorned their bomber planes.

T HE STYLE HAS CONTINUED TO GROW in popularity, and today there is a form of the original pinup style from back in the day. It has similarities to boudoir but is clearly a different style. Pinup usually depicts the subject in a sexual but sometimes humorous way.

The pinup style originated with the Vargas Girls—models and Hollywood stars of the 1940s painted by Alberto Vargas. The images were featured in *Esquire* magazine and later painted on World War II aircraft. At this same time, Gil Elvgren began photographing glamorous pinups, and his technicolor fantasies of the American Dream were just the thing for America in its post-Depression low. Elvgren was considered to the "Norman Rockwell of cheesecake," and his photographs, enhanced with painting, created gorgeous and unreal images of women with long legs, flamboyant hair, and gravity-defying busts. These images were morale boosting for homesick fighting GIs.

In the 1940s and 1950s Bernard of Hollywood became a sought-after photographer of stars and starlets, including Jayne Mansfield and Brigitte Bardot. During this time, a little known face, Norma Jean Baker, later known as Marilyn Monroe, posed naked for photographer Tom Kelley. The photographs were featured in *Playboy*'s first issue in 1953. Posing on red velvet sheets Marilyn was quoted as having "nothing on but the radio." *Playboy* continued the monthly pinup special, and the medium found its way into everyday Americana.

Glamour portraits from the golden age of Hollywood have a new champion of this style of classic pinup photography. Robert Alvarado is a highly talented photographer who is rejuvenating the classic pinup style. His work is widely known in the United States and beyond. His images are detailed and creative and show his passion for pinup. Alvarado credits exposure to these pinups of the 1950s during his critical adolescent years as inspiration for his photography. Taking these vintage-style shots and turning those memories into an art form is his passion. He cites great influences from photographers Gil Elvgren, Alberto Vargas, and Olivia, as well as Norman Rockwell, in their images, use of color, and beautiful women. He brings a refreshing enthusiasm to his work and claims that he is like a big kid when shooting someone.

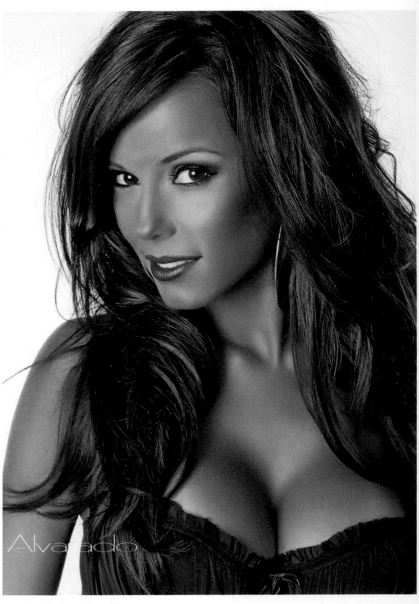

Examples of Robert Alvarado's pinups.

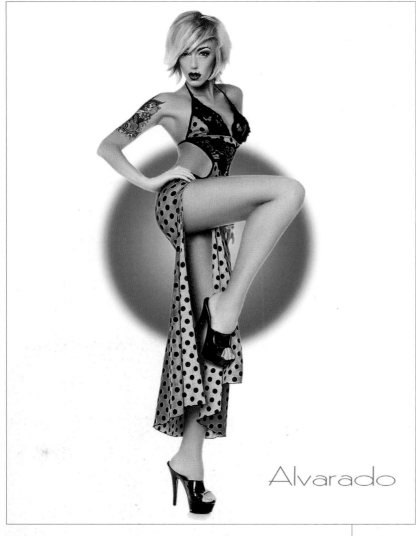

Alvarado

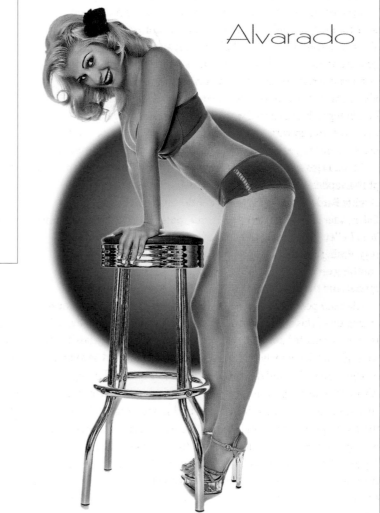

Alvarado

Implied nude

Implied nude is a style that implies the subject is completely nude but shows only parts of the subject's body. There are several clever ways of achieving this effect to obtain a sexy but tasteful shot.

OFTEN A COMPLETELY NUDE model can be partially covered with a prop to make an image much more compelling than if the model were in plain view. Props are invaluable for implied nude photographs, and they are often used in a strategic way such as a bedsheet to cover the subject partially to make it look as if she has nothing on underneath even if she does. You can use clothing or other thoughtful props, such as pillows, fruit, furniture—just use your imagination. To capture the figure nude, but avoid the image actually being a nude, you can shoot in silhouette and meter for the light background. Have the subject stand in the window or by a doorway in a dark room and meter for the light coming in to create a dramatic shot. Don't forget to pose the subject to show off her curves!

The model could be cast fully into shadow to only show a part of her body just by changing the angle you are shooting from. This type of image is very sexy, but still keeps the subject's modesty in check. There are many ways to create an implied nude. Certain poses can imply nudity without actually showing very much. Have the subject lie on her stomach at a slightly turned angle and shoot directly toward her to imply nudity. Some subjects may actually be nude; however, not showing everything makes it an implied nude image. Having the subject use her arms and legs to cover body parts will imply nudity just as well. Have the subject sit with her legs bent and her arms draped over to imply that she is nude. In contrast to classic boudoir, implied nude focuses just on the body. However, some boudoir shoots do incorporate implied nude images.

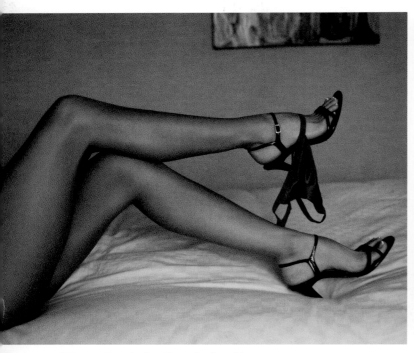

Using an extra pair of panties can imply nudity even when the client is clothed.

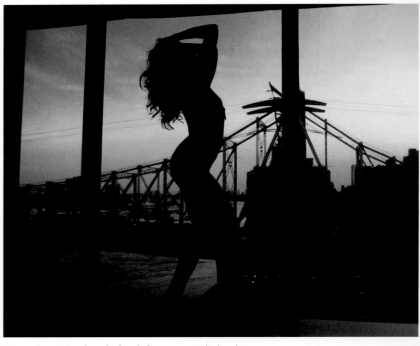

Using silhouettes to show the female form as an implied nude.

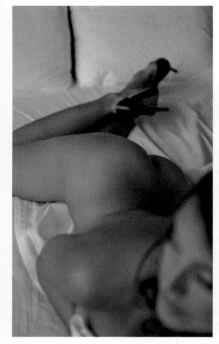

Posing can imply nudity. Have the client pose in a way to conceal private parts.

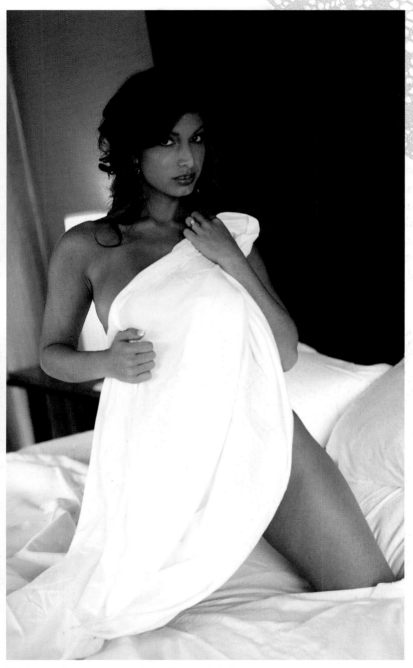

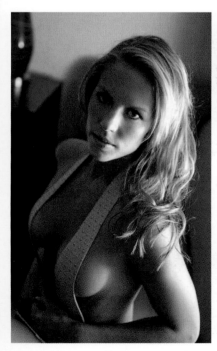

Using clothing to conceal intimate parts can be considered as implied nude.

This is an implied nude even though the client was clothed.

Reference

Glossary

ADOBE CAMERA RAW

This is Adobe's raw converter that comes with Photoshop version 7 and later. Due to its wide distribution it is considered to be a quasi-standard. ACR's philosophy is to not modify raw images at all but write any settings into an additional sidecar file called an XMP file. Adobe's Lightroom shares the same raw processing engine, and images can be interchanged.

APS

APS stands for Advanced Photo System. It is a photo format that was introduced in 1996. One of its image sizes, APS-C (Classic) with its format of 25.1 degrees—16.7mm gave name to a smaller-sized type of sensor in current DSLRs. These sensors with a size close to 24 × 16mm (depending on camera manufacturer) are being called APS-size sensors or "crop format" sensors (since they crop the classic "full frame" format of 36 × 24mm).

BEAUTY DISH

A beauty dish is a large shallow reflector for studio strobes. It usually comes with either silver or white inner coating and has a baffle mounted in front of the flash tube to suppress direct light spill from it. A beauty dish combines the shadow softening of a small softbox with the punch and higher contrast of a regular reflector.

BOOKENDS

Bookends are two large standing panels that are attached to each other, usually with duct tape or hinges. They can be made of foamcore or a wooden frame with a canvas lining stretched over them. Bookends are used as cheap, easy-to-handle reflectors (if painted or lined in white) or as absorbers (if painted or lined in black).

CALIBRATION

Calibration is the process of tuning an input or output device so that it is responding in a well-defined manner. The most important device for photographers to calibrate is their monitor to make sure it displays correct colors. Another common device to be calibrated is a printer (again, well-defined color output is the goal). To be precise, the process used for monitors and printers generally is called profiling, not calibrating, since a profile for the device is created that defines the desired behavior.

CATCHLIGHT

This is the reflection of lights in the eyes. In close-up photos it is desirable for the catchlight to consist of not too many individual spots and to be positioned close to a two o'clock or ten o'clock position. The number, shape, and position of light sources will determine this.

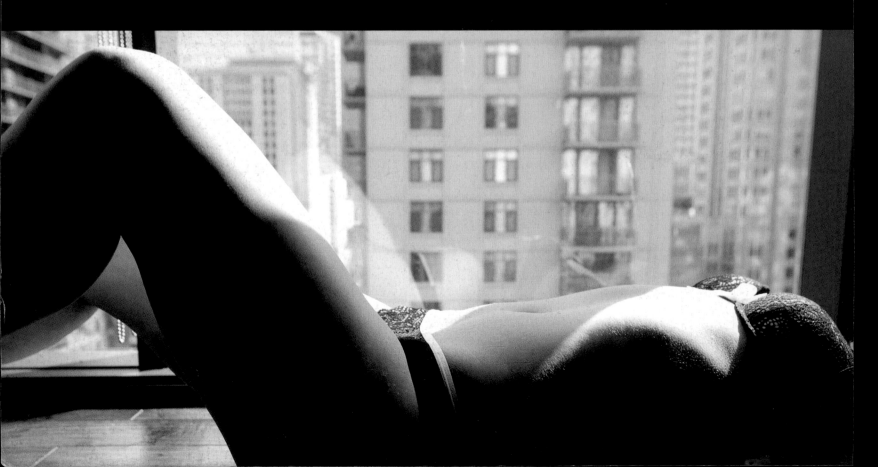

CHEAT SHEETS

Cheat sheets are any collection of images that you keep to look something up, get inspiration from, or help you to explain something to your model or hair-and-makeup artist. They can be photo prints, pictures torn from magazines, or digital images stored on your iPhone, iPad, or cell phone.

DAY RATE

A day rate is a rate that hotels may give for a room not used for an overnight stay. Hotels assume that the room is left in a state close to how it has been found to provide this reduced rate. Therefore it is important to leave rooms with a day rate in a clean and tidy state.

DEPTH OF FIELD

Depth of field (DOF) describes the range of sharpness in front of and behind the plane of focus. A large aperture (small f-stop number) will provide a shallow DOF, this can be as low as 1/32 of an inch or less. A small aperture (large f-stop number) provides a large DOF and keeps objects in the background and in front of the plane of focus sharp.

DIFFUSER PANEL

This is a translucent panel that reduces the harshness of direct light and provides soft shadows.

DRAGGING THE SHUTTER

This is a technique in which the shutter speed is set low to capture more ambient light. It works best in conjunction with a flash as the main light source. The flash's short burst time will freeze the subject's motion, whereas the shutter being open long will expose for even low ambient light.

DSLR

Digital single lens reflex camera.

FILL LIGHT

This is light that is added to the main light to reduce shadows. The most effective fill light is placed as close to the camera position as possible; however, often a light or a reflector opposite or at a 90 degree angle to the main light is used.

FLUSH MOUNT

This is an album type where images are mounted, fully covering the page without borders, frames, or mats.

GEL

The term "gel" is loosely used for any kind of filter in the form of sheets, originally originating from gelatin filters. These, however, are only a small group among all sheet filters. To gel a light is to apply a filter to a light.

GRAPHIC TABLET

This is a computer input device that is used alternatively or in conjunction with a mouse. A stylus, usually pressure sensitive, helps to control programs like Photoshop in a manner closer to sketching and drawing, allowing precise and subtle work.

GRID

A grid is used to focus light and keep it from spilling in unwanted directions. There are round honeycomb grids to be applied to the front of strobes and square fabric grids (often called "eggcrates") to be applied to the front of softboxes and octoboxes.

HAIRLIGHT

This is a light positioned in a way that hair on the head's rim is lit to make it stand out from the background. In particular, darker hair in front of a dark background can get completely lost without a hair light. It is positioned above and behind the subject's head, just out of the frame.

HMI

Hydrargyrum medium-arc iodide lamp; these are continuous-light lamps with a very high efficiency and a color temperature close to daylight (6,000 K). HMI lights used to be restricted mostly to the movie industry due to their high price. However, in recent years several affordable small HMI lamps have become available.

HOT LIGHT

All continuous lights besides LED and fluorescent lights are called hot lights due to their high operation temperature.

ISO

International Organization for Standardization; in photographic context it describes film sensitivity or, for digital cameras, light sensitivity. Higher numbers mean more sensitivity.

LIGHT MODIFIER

Any object that changes the characteristic of a light source. Light modifiers can be reflectors, umbrellas, softboxes, barn doors, snoots, and more.

LOSSY COMPRESSION

A compression method that reduces the size of a file with varying or adjustable loss of data. JPEG is an example of a lossy compression.

Glossary

MACRO

A special lens that allows getting close enough to the subject to get a reproduction scale of 1:1. This means that the subject's projection on the film or sensor is as large as the object. Macro lenses can also be used as regular primes.

METADATA

Any information in an image file other than the direct image-forming pixel data. Metadata is all kinds of non-modifiable information like aperture, shutter speed, camera brand, make and serial number, and much more (EXIF data). It is also user-writeable information like location, copyright, date, time, and so on (IPTC). Lastly, metadata can be information that defines the final processing and therefore the look of the image. This can be exposure, white balance, color or camera profiles, contrast, and more.

ND FILTER

A neutral density filter is a gray filter with the sole purpose of reducing light. Good ND filters should be absolutely neutral, without any color cast.

OCTABOX

This is a softbox with an octagonal shape (eight corners) instead of a rectangular shape. Catchlights and other reflections of octaboxes have a less distinct reflection than rectangular light sources.

PRIME

Prime lenses are fixed-focal-length lenses (in contrary to variable-focal-length zooms). They usually provide larger apertures, and due to their less complicated design often are the sharpest lenses available.

RADIO TRIGGER

With these devices you can trigger and sometimes also control remote flashes (or cameras). There are very simple radio triggers that release only a remote flash, and there are also some that can transmit TTL control to make a remote flash act like an on-camera TTL flash.

RAW

Raw is a manufacturer proprietary image format that all DSLRs and many point-and-shoot cameras provide. It stores unmodified image information alongside any capture parameters (shutter speed, aperture, and so on). It also stores parameters that were set in-camera (like sharpening and contrast), as well as other non–image forming data (like camera make and serial number). Raw files differ from all other photographic image formats, like JPEG and TIFF, in that many parameters can be changed and reapplied in specialized software (raw converters) with little or no loss to image quality.

SLR

Single lens reflex camera. A camera that uses a mirror to show the same image in the viewfinder that the lens projects on the film or sensor. Virtually all professional-grade, still-image cameras currently are of the SLR type.

SOFTBOX

A softbox is a light modifier that enlarges the light source and at the same time prevents light spill to the side and back, thus providing a more controlled light than, for instance, umbrellas do. Softboxes are made of a black fabric housing with white translucent fabric on the front. The inside can be white or silver, and the box usually is supported by rods, similar to a tent.

SPEEDLIGHT

Speedlight is originally a term used by Canon and Nikon (Canon uses "Speedlite") to describe their on-camera TTL flashes. However, the word nowadays is informally used to refer to all small external flash units of any brand.

SPLIT TONING

Split toning applies different colors and/or saturations to the lighter (highlights) and darker (shadows) parts of an image. It can be used to tint only one of the two or, for instance, to achieve more pleasing sepia tones than equal tinting from bright to dark would yield.

STROBE

Strobe is the term used for flashes used in studios. There are two main groups: compact flashes that contain all the controls and electronics, and flash heads + generators. The flash head contains only the flash tube and a reflector, and all the controls and electronics are contained in the generator block, which is hooked up by cable to the flash head.

TEAR SHEETS

Tear sheets are pages ripped out of magazines, or images found from other sources for inspiration.

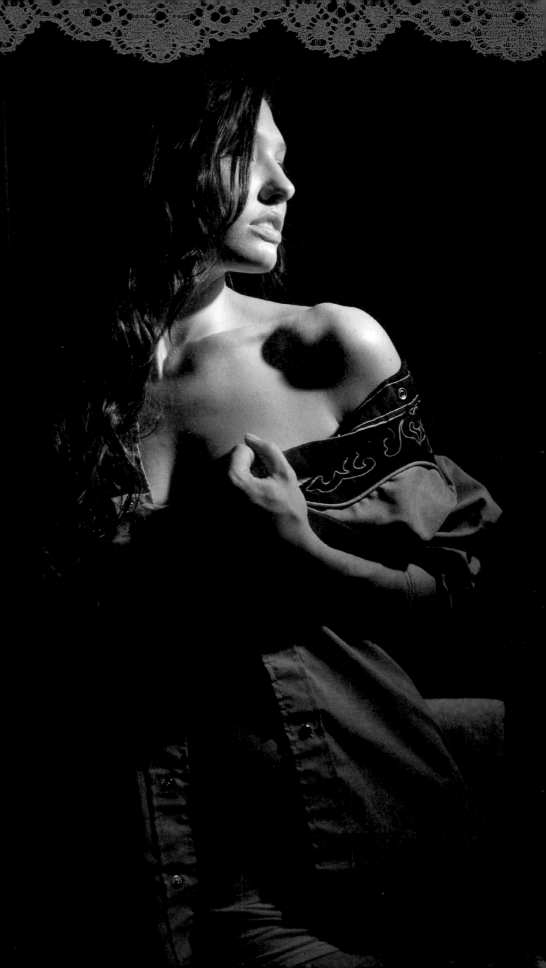

TILT/SHIFT LENS

This is a lens in which parts of it can be shifted up and down and sideways as well as tilted. By shifting, a different field of view can be captured, similar to shooting with a wider lens and then cropping parts away. Tilting modifies the plane of focus, which usually is parallel to the film or sensor. The result is that sharp portions of the images can run toward or away from the camera.

TTL METERING

Through the lens metering. This is light metering that the camera acquires from the same image that also hits the film or sensor. Basically it is what enables all modern cameras to meter and more or less automatically achieve perfect exposures.

VIDEO LIGHT

These lights are small continuous LED or halogen lights that, even though made for the video industry, serve very well as flexible and portable lights for still photography. Most of them are battery powered, and some of them use filters to provide daylight-balanced as well as tungsten-balanced light.

WORKFLOW SOFTWARE

This is a term for a software breed that appeared about five years ago. It usually combines image processing with cataloging and other tasks like generation of books, websites, and other administrative tasks. The most popular systems are Apple's Aperture, Adobe's Lightroom, and Phase One's Capture One.

XMP FILE

XMP stands for extensible metadata platform. It is a standard for information relating to the file's contents. In conjunction with (Adobe) raw processing, XMP contains all the settings that have been applied to an image in the raw processor.

Web resources

The Abie Strap
www.abiestraps.com

Adorama
www.adorama.com

Adobe
www.adobe.com

Alien Bees (lighting)
www.alienbees.com

Alien Skin (plug-ins)
www.alienskin.com

anthropics (Portrait Professional)
www.PortraitProfessional.com

Apple
www.apple.com

Bay Photo Lab (photo calendars)
www.bayphoto.com

BPN (Boudoir Photographers Network)
www.boudoirphotographers.net

Canon
www.canon.com

Clear Bags
www.clearbags.com

Color Right (white balance card)
www.colorright.com

Creations Hair and Makeup
www.creationshairandmakeup.com

DWF (photographers' online forum)
www.digitalweddingforum.com

E Motion Media
www.emotionmedia.com

Finao Albums
www.finaoonline.com

Fundy Software for Photographers
www.fundysos.com

Gracie Designs (custom album covers)
www.shopgraciedesigns.com

Ice Society Photographers Resource
www.theicesociety.com

Imagenomic (plug-ins)
www.imagenomic.com

Jolie Wraps
www.joliewraps.com

Kelly Moore Camera Bags
www.kellymoorebag.com

Kubota (actions + presets)
www.kubotaimagetools.com

Lastolite (lighting)
www.lastolite.com

Lavalu Image Processing
www.mylavalu.com

Lowel (lighting)
www.lowel.com

Mama Shan (actions)
www.photoshopmama.net

Manfrotto Imagine More
www.manfrotto.com

Nik (plug-ins)
www.niksoftware.com

Nikon
www.nikonUSA.com

onOne (plug-ins)
www.ononesoftware.com

Phase One (raw converter)
www.phaseone.com

PhotoBucket (image hosting)
www.photobucket.com

Photographers Tool Kit
www.photographerstoolkit.com

Photoshop Fitness
www.photoshopfitness.com

PickPic (online gallery)
www.pickpic.com

Pictage (online gallery)
www.pictage.com

PocketWizard
www.pocketwizard.com

PPA
www.ppa.com

Preset Heaven
www.presetsheaven.com

Pro DPI Pro Lab
www.prodpi.com

Raw Pudding (image processing)
www.rawpudding.com

Red Cart (online gallery)
www.redcart.com

Shoot Sac (camera bags)
www.shootsac.com

Shoot Q (online studio management)
www.shootq.com

Simply Canvas
www.simplycanvas.com

SmugMug (online gallery)
www.smugmug.com

Spilled Milk Designs (custom websites)
www.spilledmilkdesigns.com

Stella Kae Pro Stylist
www.stellakae.com

StudioCloud (management software)
www.studiocloud.com

Think Tank Photo
www.thinktankphoto.com

TRA (Totally Rad Actions)
www.gettotallyrad.com

Triple Scoop Music (royalty-free website music)
www.triplescoopmusic.com

wacom (graphic tablets)
www.wacom.com

WHCC (photo lab)
www.whcc.com

WhiBal (white balance card)
www.rawworkflow.com

WPPI
www.wppionline.com

X-Rite (white balance card)
www.xritephoto.com

Zenfolio (online gallery)
www.zenfolio.com

Index

Acknowledgments

I am so blessed and lucky to have the most amazing family, friends, clients, and business associates. I truly feel that if you respect others and are true to yourself, the people who come into your life will treat you just as well.

* To my photography friends who inspire me to be the best I can be. Mark Lutz, Jeff Caplan and all my DWF friends—you are my extended family and I don't know what I would do without you. Thank you, Ray Prevost, for teaching me so many awesome Photoshop techniques—seriously dude, you rock! Harold Jankowiak, I love your excitement and your craziness and the fact that you are so genuine. I appreciate all your support of Couture Boudoir®.

* To my best friend for supporting me through good and bad times and being there for me through all my personal and business journeys—Margaret Hooks, you are the best! XOXO

* My boudoir business would not be nearly as beautiful without the amazing women behind the styling—Joni Lineberger, Stella Kae, and Holly Neal. Each of you hold a special place in my heart, and I love working with you.

* To the amazing team at Ilex for helping me through this project and creating such a beautiful book, in particular, Adam Juniper, Natalia Price-Cabrera, and Tara Gallagher.

* To my wonderful sponsors for supplying the awesome products for myself and my students. Having great products to work with sure makes work more fun.

* To my sister and assistant, Cindy Helton, you are the best, and I am so spoiled not only by having an awesome assistant but having an amazing sister.

* One of the people who means so much to me—Debbie Hyde, without you this book would not be as pretty. From model to friend I am so grateful you are in my life.

* Thank you to Robert Alvarado, one of the world's top Pinup artists for contributing some of his amazing images to this book (pages 146–147). www.iiephotography.com

* To the readers of this book—thank you for taking the time to learn from me. I feel like I learn just as much from all the wonderful people my path crosses by teaching.

* My Thomas, once again you are my rock. Words cannot describe how lucky I am.

* To my parents, even though you are in heaven I know your love and support are still here with me. I miss you and love you very much.